RONALD W. WOHLAUER

EYE OF THE STORM

DAVID R. GODINE · PUBLISHER · BOSTON

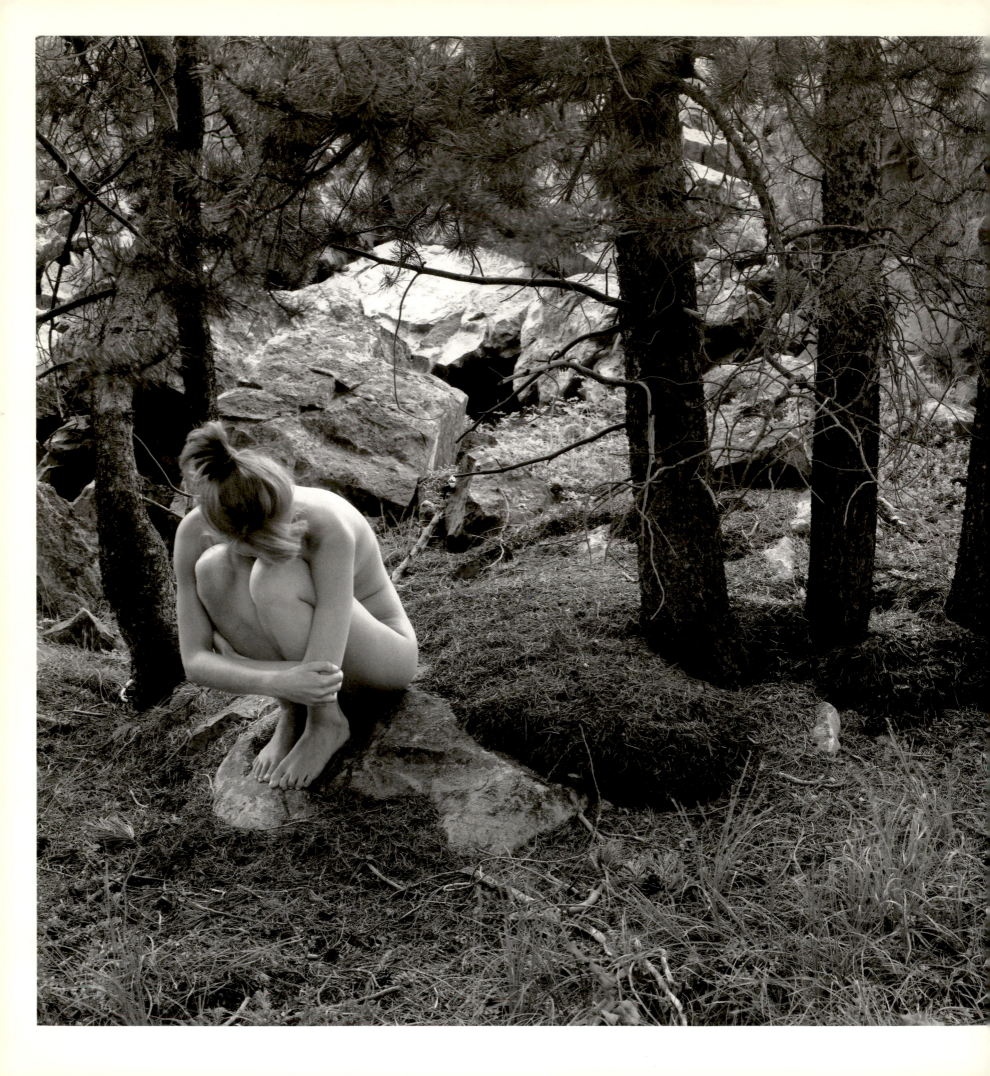

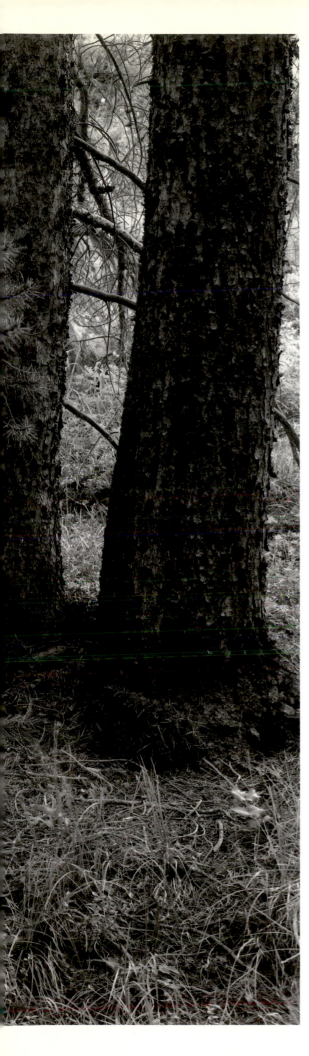

NUDE IN FOREST, *Colorado 1975*

RONALD W. WOHLAUER

EYE OF THE STORM

[Contemporary Photography Series, No. 5]
— press release

ISBN 0-87923-548-9 (cloth) 0-87923-547-0 (paper)
Library of Congress catalog card number 84-81282

First Edition

Printed in the United States of America

DEDICATION: *To Robin*

There's nothing like a breakfast of smoked kippers and porridge to give you a bright outlook on life. I had been tipped off by my Scottish landlady that some families would be bringing their sheep down from the moors later in the morning for shearing and I wanted to be there. The one-lane road looping around the Isle of Barra is only eleven miles long from start to start so I had no trouble locating my destination, but when I arrived the place was deserted except for three parked cars. I set up my camera but felt a bit self-conscious focusing into an empty pen. Where were the sheep? I couldn't see anything — just a vast stony landscape in every direction — but I thought I heard a volley of whistles from behind the hill. The darkcloth over my head muffled the sounds of men yelling orders to their dogs, and swearing, in Gaelic. They were coming. It occurred to me that my knowledge of sheep is limited to an affection for Shetland sweaters. In fact, I hadn't the foggiest idea how they would ultimately transport themselves from their present location to mine. Had I planted myself smack in the crossfire of trampling hoofs, border collies, and Scottish crofters? I was beginning to taste the kippers. Suddenly, a man scrambled over a rocky ledge with his sheep crook and fast behind him his flock tumbled down the ravine. Within seconds, it was bedlam. Bleating, yelping, shouting, the sheep charged toward me, frantically looking for an escape route. The dogs darted at their heels and abruptly turned them into the pen inches from my feet. I released the shutter.

Page 8, Sheep Shearing

In contrast to this creative bedlam, my photographs — claim the critics — come out serene. It must be the sort of quiet one finds in the eye of a storm. I am not a serene person. I do not work in a serene atmosphere. The 8x10 view camera is a beast. It weighs in at thirty-five pounds when finally outfitted with its lens, film holder and tripod. It is clumsy and bulky. It is slow. The process of making a picture is laborious, deliberate, grinding. Yet like a heat-seeking missile, my camera is drawn to targets that are fleeting and evasive. By choice, I have deployed a nearly immovable object (the big camera) into battle against the irresistible force of nature's transience. My camera collides with the elements and out of this battle emerges, surprisingly, an image of serenity.

INTRODUCTION

Take the day I set up my camera on the old Coast Road that parallels California's Big Sur highway. Over my shoulder a succession of squalls lined up at sea and with an erratic unpredictable rhythm they advanced inland through my picture frame. Their ferocity sent me running to the car for cover, abandoning my instrument to the minimal protection of its darkcloth. Each attack was punctuated by a broad sweep of light which washed across the landscape from right to left but quickly retreated as the next barrage of rain and wind rushed past. Fragments of the composition would be illuminated and then dissolve. I dashed back and forth until finally, as if marshalling its forces for the next onslaught, the wind hesitated. The sun pierced the clouds and for one brief exquisite moment it stalled over the wet road, setting it ablaze. I made one exposure, then threw my gear into the car before another squall could send its drenching spray my way.

As a tool, my camera is capable of great precision, clarity, tonal range, depth of field and optical fidelity. My pictures couldn't be made without it. But it doesn't lend itself well to the quick "grab shot." When I arrived at an Orkney farm one late afternoon, the dairy cows were standing alert, neatly arranged in a tidy line at the fence. Now, I know these are not prodigiously talented animals, but I thought they would at least be capable of withstanding a one-second exposure. All I had to do was set up my camera. Just the usual routine: Extend tripod legs; tighten each. Screw camera onto tripod head. Select a lens. Grab darkcloth, light meter, box of film holders. Choose desirable location. Throw darkcloth over head, tilt back standard to correct perspective. Adjust front standard for depth of field. Focus from the back again. At each stage remove 7x magnifying loop from pocket for critical focusing. Compute exposure from multiple light readings. Determine shutter speed, f. stop, development time in darkroom. Close lens, stop it down, set shutter. Hunt for the next unexposed piece of film from ten identical numbered plastic film holders. Open back of camera. Insert film. Withdraw darkslide. Emerge from under darkcloth. Squint. Notice cows are gone.

At this juncture one can proceed in two ways. One is to repeat steps one through thirty in a new location. The other is to appeal to the cows' sense of obligation to the sabotaged but earnest photographer and his worthy artistic enterprise. Understandably, I chose the latter. I mooed at them plaintively, and at length, I persuaded them to return to the fence. For a one-second exposure. Piece of cake.

Miraculously, I wooed the cows. But what does one do when the image does the wooing? While travelling through the Trossachs valley in October, I came up against one of those legendary Scottish days which are assiduously side-stepped by the travel brochures. The downpour was relentless, visibility nil. An upward glance confirmed that no relief was in sight. But a sideward glance revealed an oak forest so spectacular, so primordial in its drenching gloom, that I was seduced. The Brothers Grimm never coaxed a child more compellingly into an enchanted forest than this one summoned me. I bravely marched into the rainy darkness clutching my camera. The seduction was spontaneous, but the conquest would require complete control. It took four minutes of exposure to accumulate enough light to make that picture of oak trees. I was soaking wet. I was ecstatic.

It's a strange view of the world one gets with one's head shrouded under a black darkcloth. It's like looking through a tunnel only upside down and backwards. And while I'm struggling with the day's transcendent artistic issues such as how to get rid of a telephone wire which has suddenly materialized from nowhere or a vapor

trail which is about to destroy a complex composition, the spectacle of this "old-fashioned squeeze box" forever gathers curious onlookers. Many times I've glanced down from my ground glass only to notice a pair of shoes standing next to mine. On rare occasions I can incorporate them into the picture as I did with the Orkney farmer who struck up a friendly conversation about the high cost of butter since the Common Market debacle, a topic I know nothing about. More often though, traffic piles up around me. Well-intentioned locals scan the scene I've chosen and conclude that it isn't worth my time and trouble. "This is nothing! The really good stuff is down the road, only three miles further. Wait until about 4:00 then shoot east. Ta!" He knows. He's made that picture himself. Tourists invariably interpret my presence as a signpost which reads, "Photo opportunity. Stop here." Never mind that I'm focused on a few square feet of cracked mud dead ahead. I realize that mud isn't the kind of material that strikes absolutely everybody as a dramatic subject, so they quickly click off a few shots of the Panamint Mountain Range eighty miles in the distance and speed away, leaving us both satisfied.

I spent one dreary morning poised and ready in front of the Standing Stones of Callanish on the Island of Lewis, a remote corner of the Outer Hebrides. Having invested the better part of three hours impatiently waiting for a picture to come together in that one spot I felt I had earned the exclusive rights to it. Not true. At the very instant the drizzle stopped, a van assaulted the hill on which my wife Robin and I were parked. Twelve nature lovers swarmed into my picture, never noticing me cursing them silently for spoiling its pristine isolation. The tour director was an Englishman decked out in plus fours and a deerstalker hat and when he shimmied up one of the ancient monoliths to take a snapshot I was amazed to find him perfectly focused and composed in the middle of my picture. The darkslide had already been withdrawn from the holder and "Man on Standing Stones" was captured. I stood there speechless. Who would have thought that the eye of this storm would have contained a tour guide perched unnaturally, illegally, on an ancient sacred stone?

It's midday in front of the Victor Hugo Delikatessen. Judging from the commotion, it seems as though all of Edinburgh has simultaneously chosen this moment to search out their perfect smoked salmon. A young woman parks her bicycle against the wall and disappears within, the bicycle fairly quivering with its recent motion and the anticipation of being on its way again. A delivery truck hovers on what I've just defined as one perimeter of my frame; when its driver will choose to start it up again is anyone's guess. A gang of boys loitering on my other edge is still unsure of its direction. I watch this scene at each second of its unfolding; the boys on the left, the boys marching across the front window, the boys exiting stage right. Traffic, noise, customers, confusion. I must content myself to wait until my moment presents itself. When it does, if it does, it will look (as it does) as though the bicycle has been leaning stiffly against that wall for days, as though the shadowy figure in the upstairs window has all the time in the world to watch the scene below. No one would guess that he'd just flung back that curtain and that my stomach churns with the need to focus my camera, pull back the darkslide and fix him in that pose as if he had been there forever.

Simply put, I love making photographs. My approach can be described as falling somewhere in that gray area between fanatic and obsessive. I freely admit it. There is something immensely satisfying about plunging into the eye of the storm and nailing a picture down while all hell may be breaking loose just outside the frame.

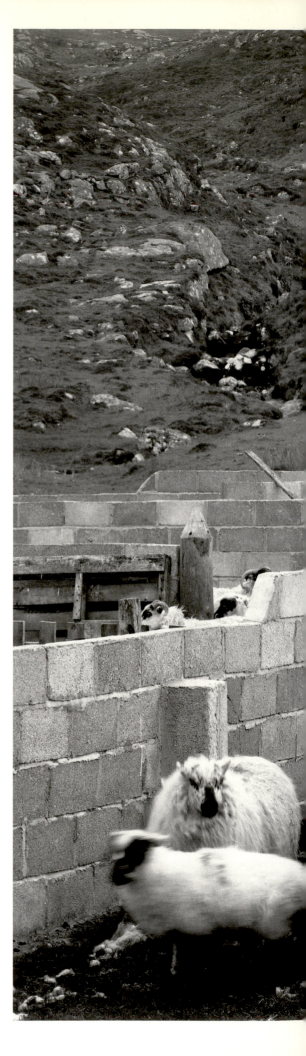

SCOTLAND

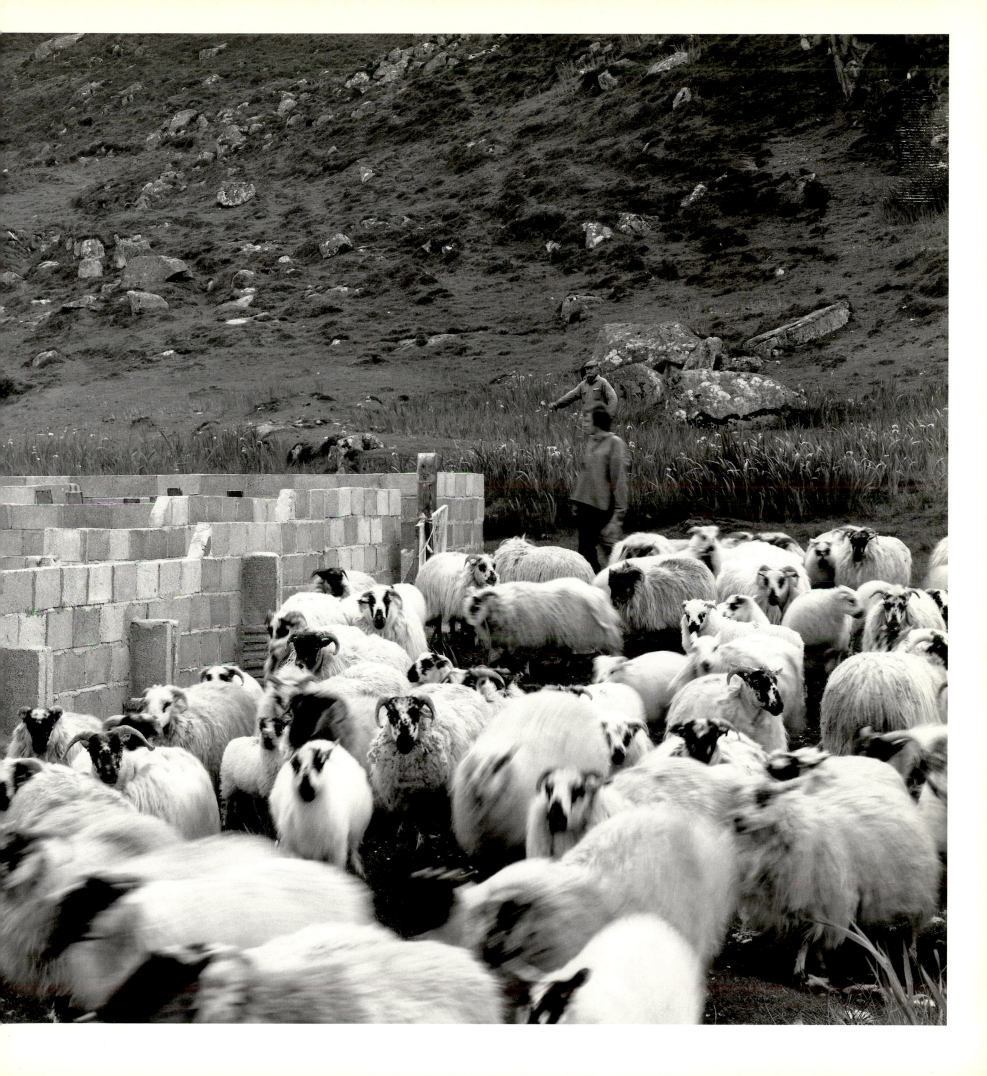

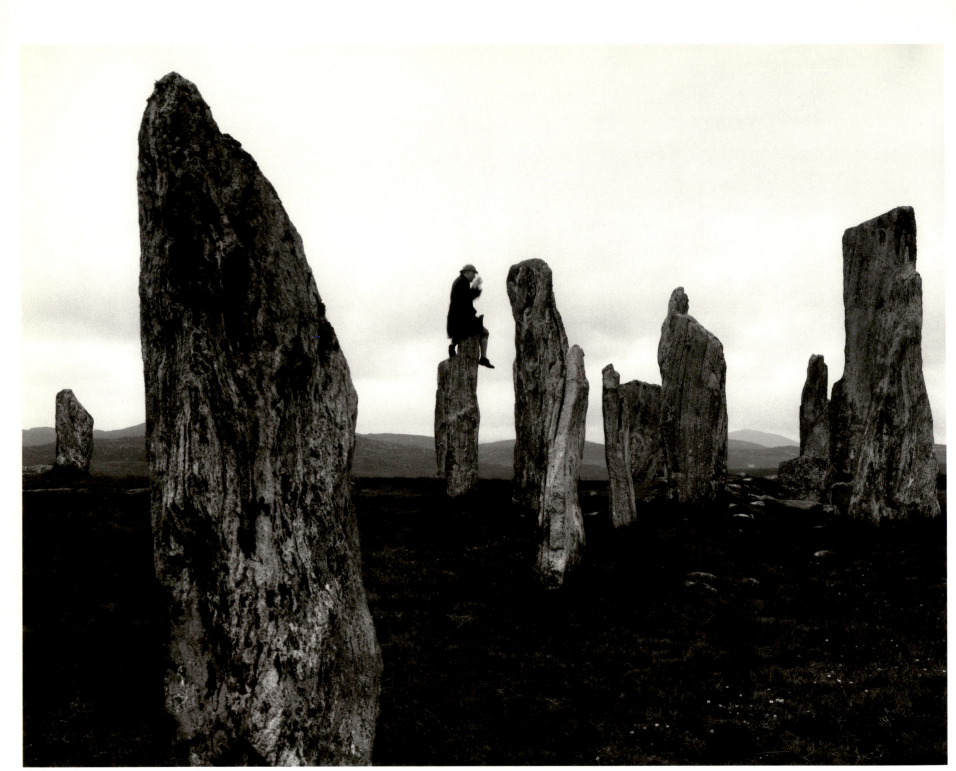

MAN ON STANDING STONES, *Isle of Lewis 1976*

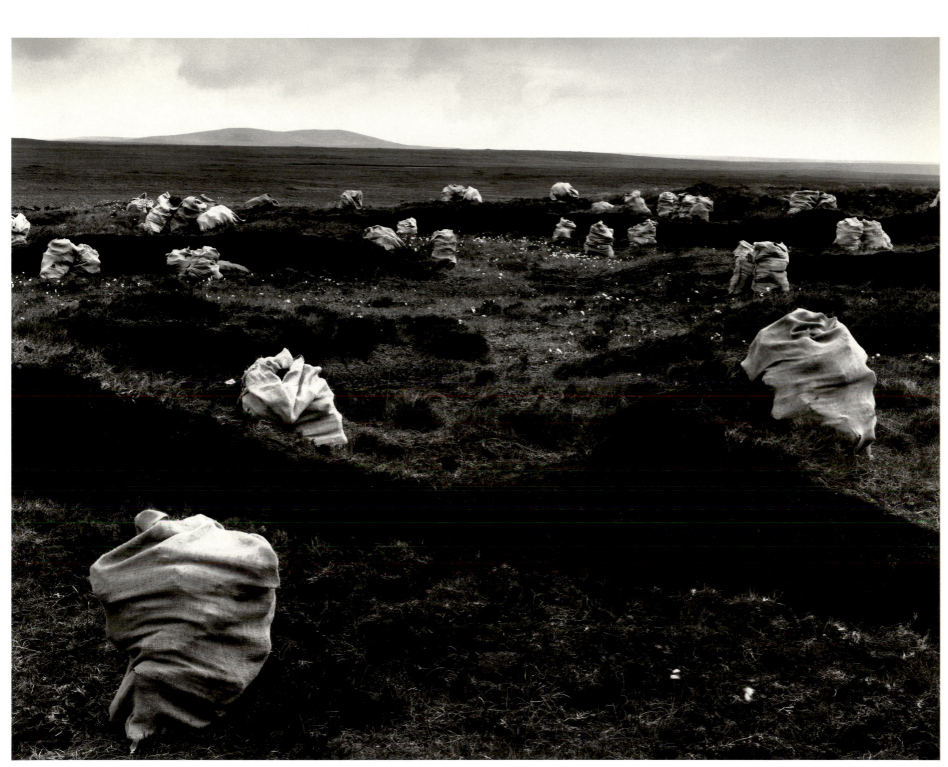

PEAT BAGS, *Isle of Lewis 1977*

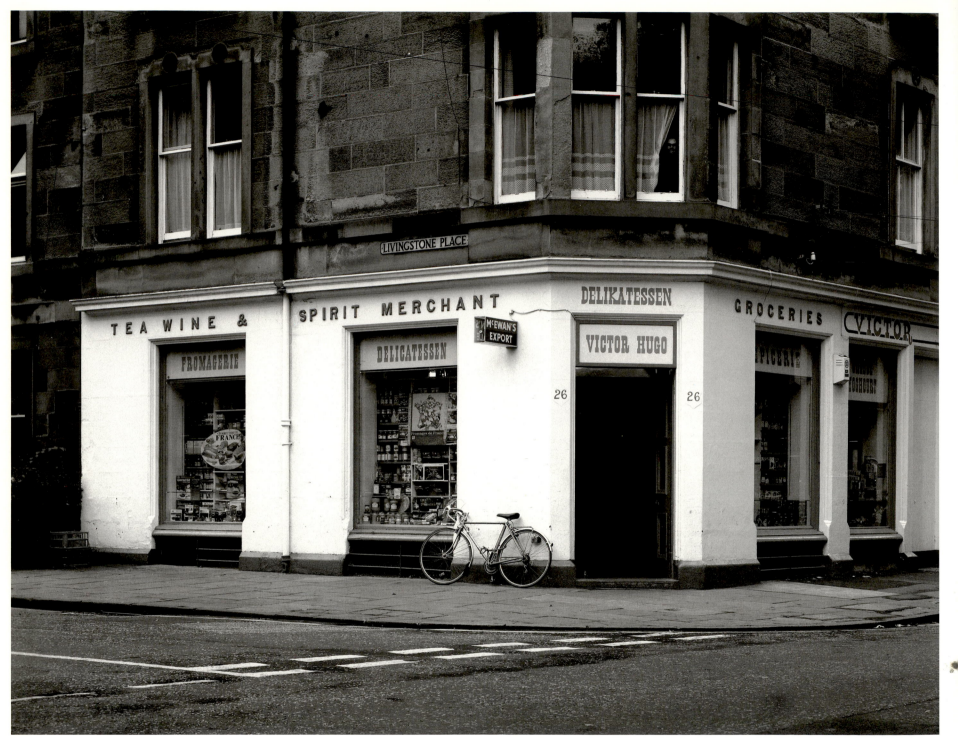

VICTOR HUGO, *Edinburgh 1983*

WHITE HOUSE, *Elie 1983* A. LURIE, *Edinburgh 1983*

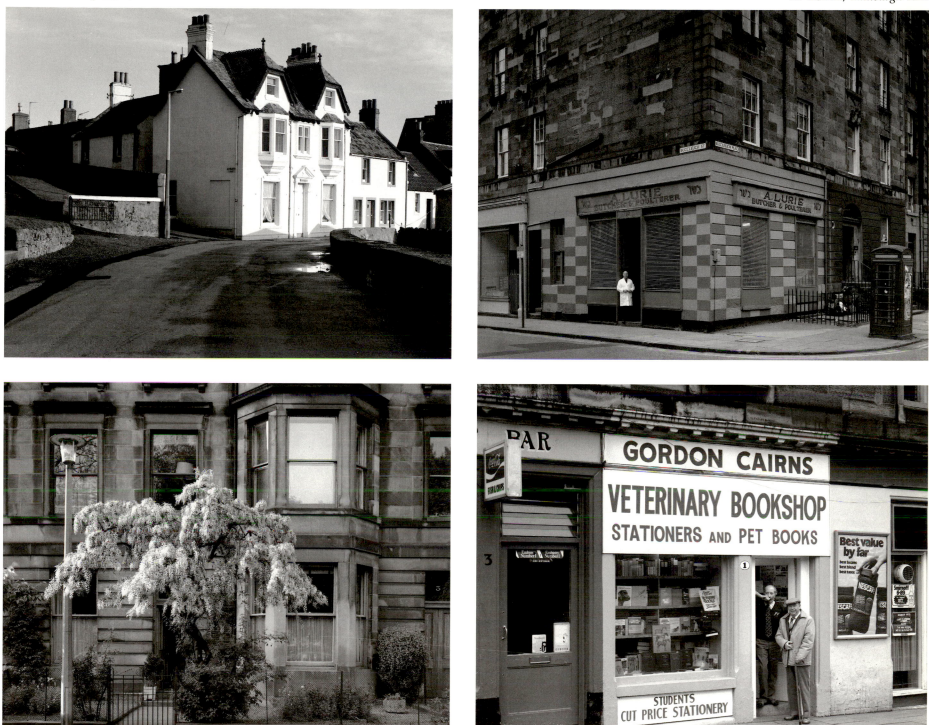

BLOOMING TREE, *Edinburgh 1980* GORDON CAIRNS, *Edinburgh 1983*

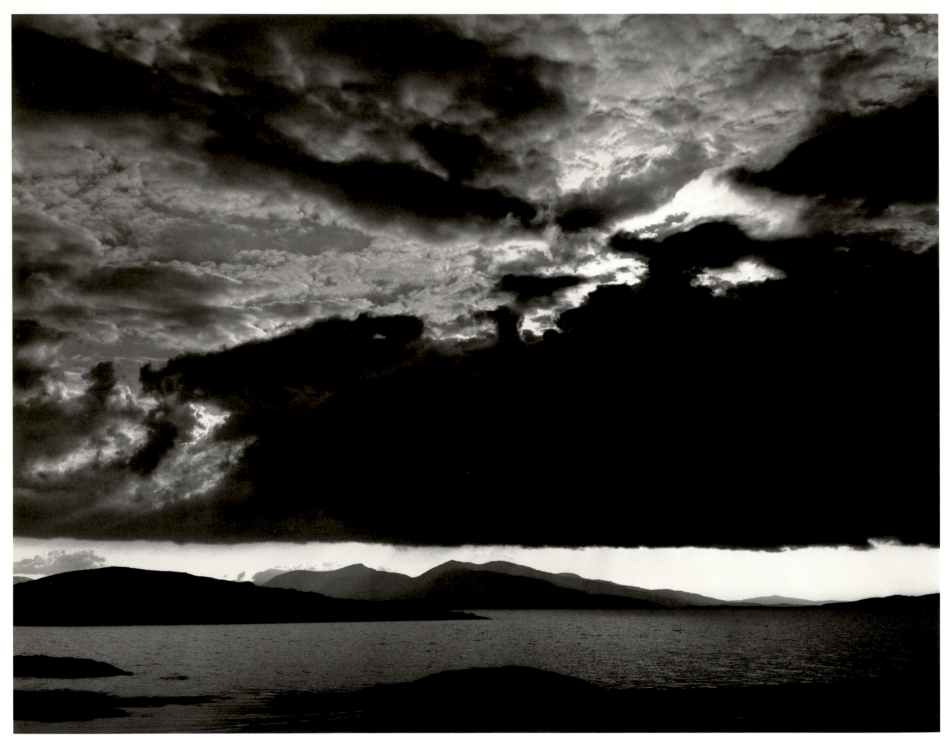

STORM FRONT, *Oban 1980*

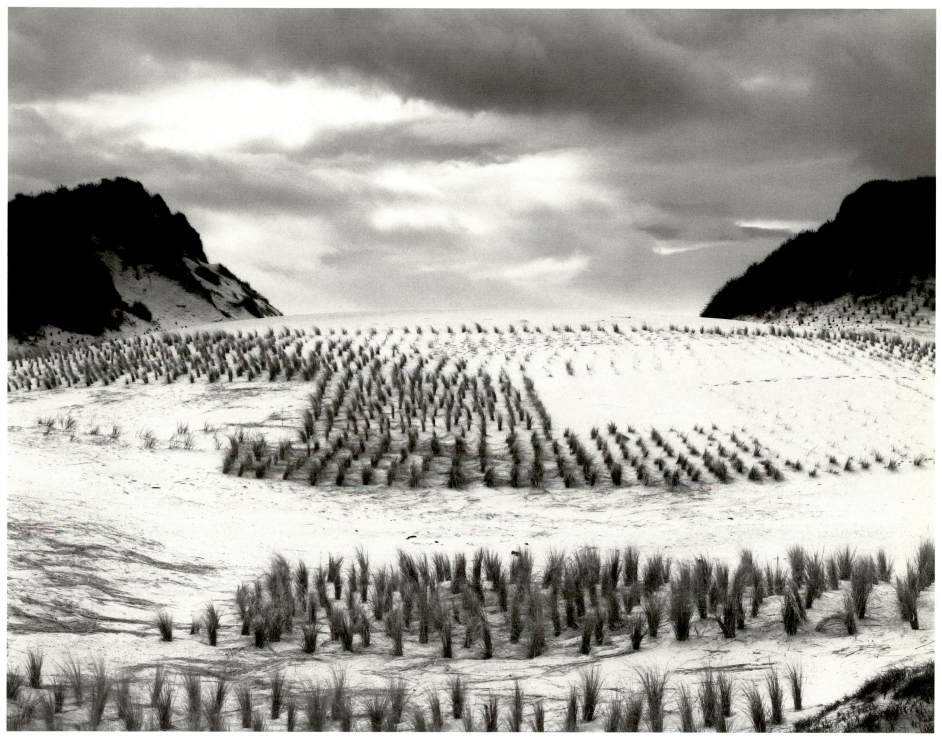

DUNE GRASSES, *Isle of Barra 1980*

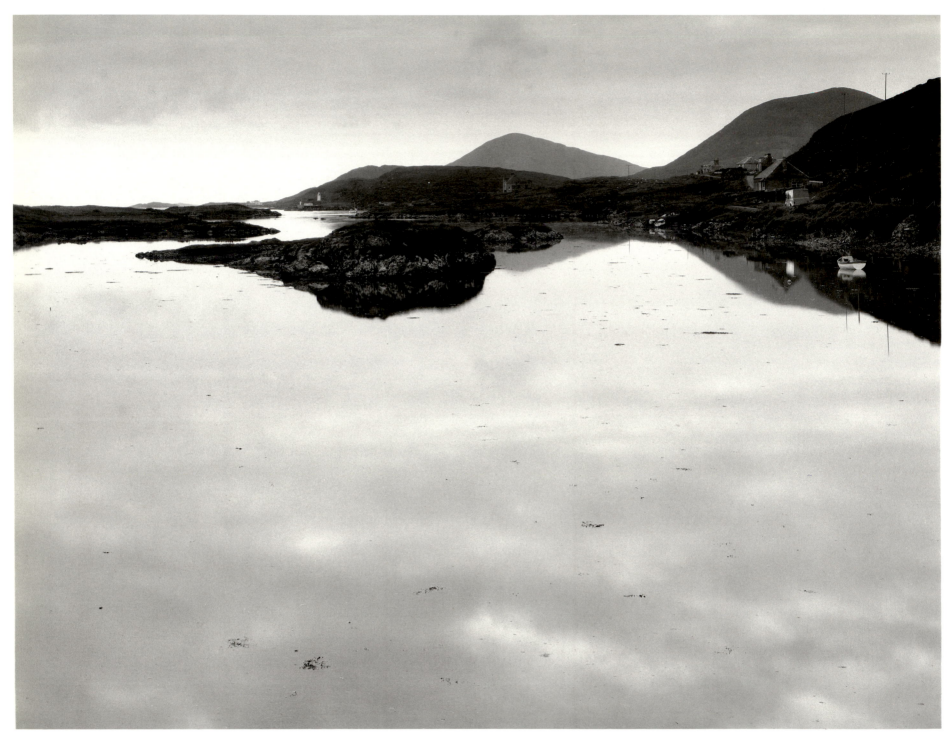

STROND, *Isle of Harris 1976*

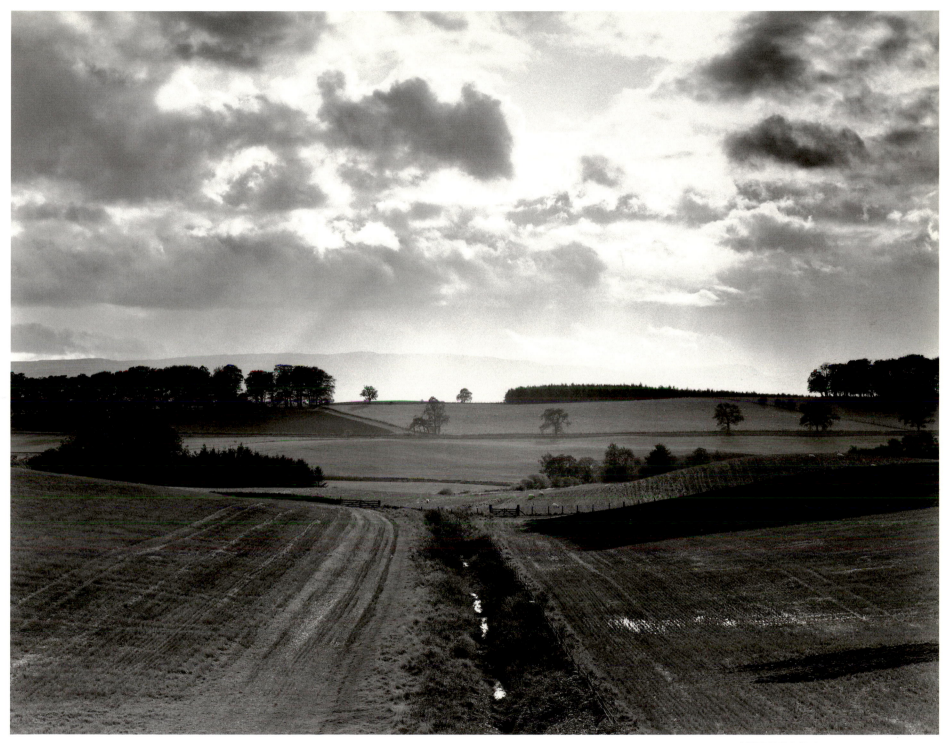

AUTUMN STORM, *Argaty Road 1983*

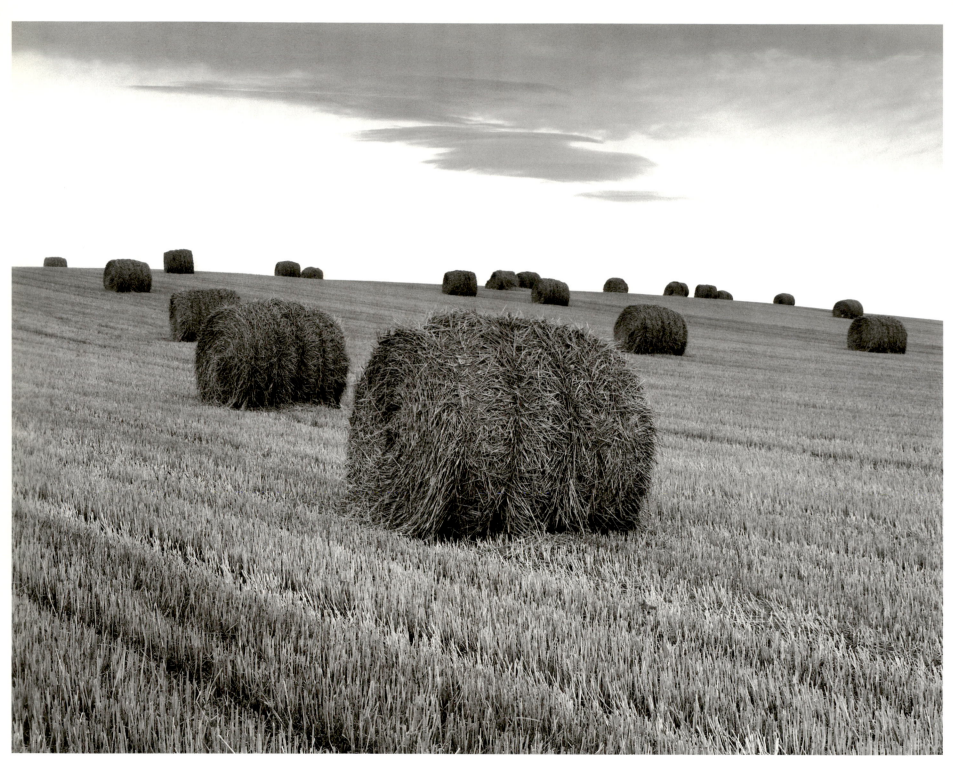

HAY ROLLS, *Fifeshire 1983*

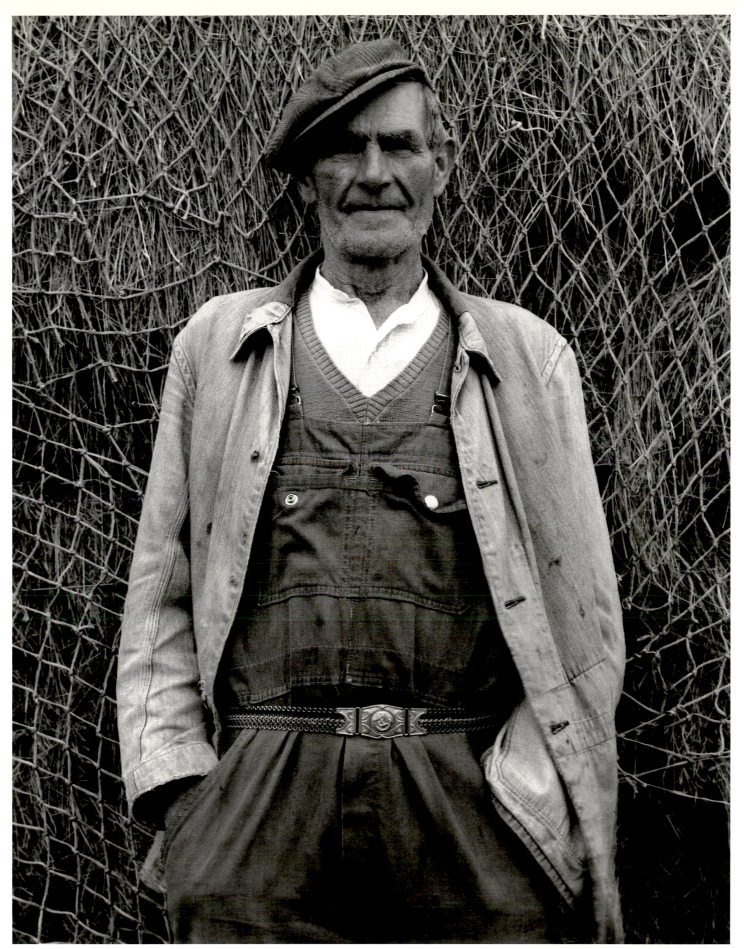

ORKNEY FARMER, *Orkney Islands 1977*

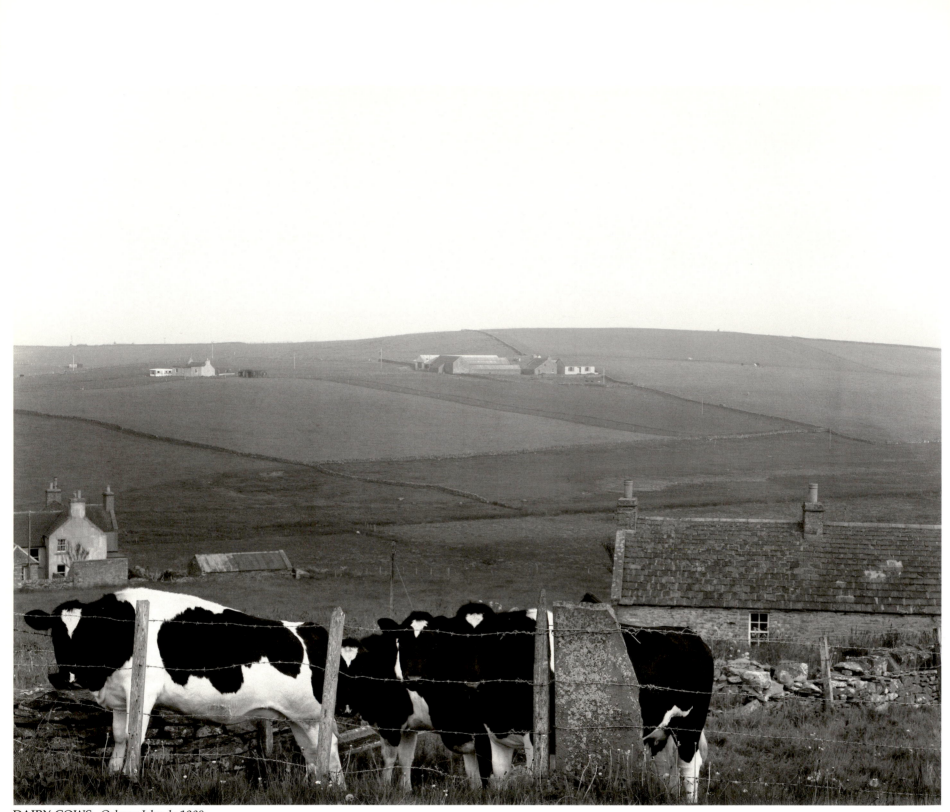

DAIRY COWS, *Orkney Islands 1980*

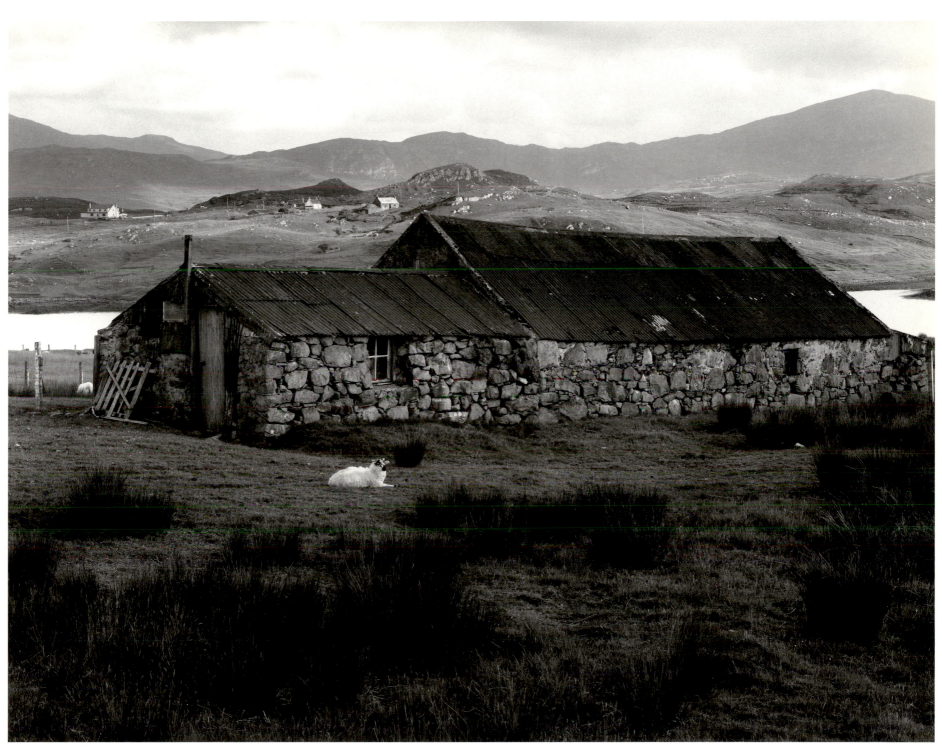

SHEEP, *Balallan, Isle of Lewis 1980*

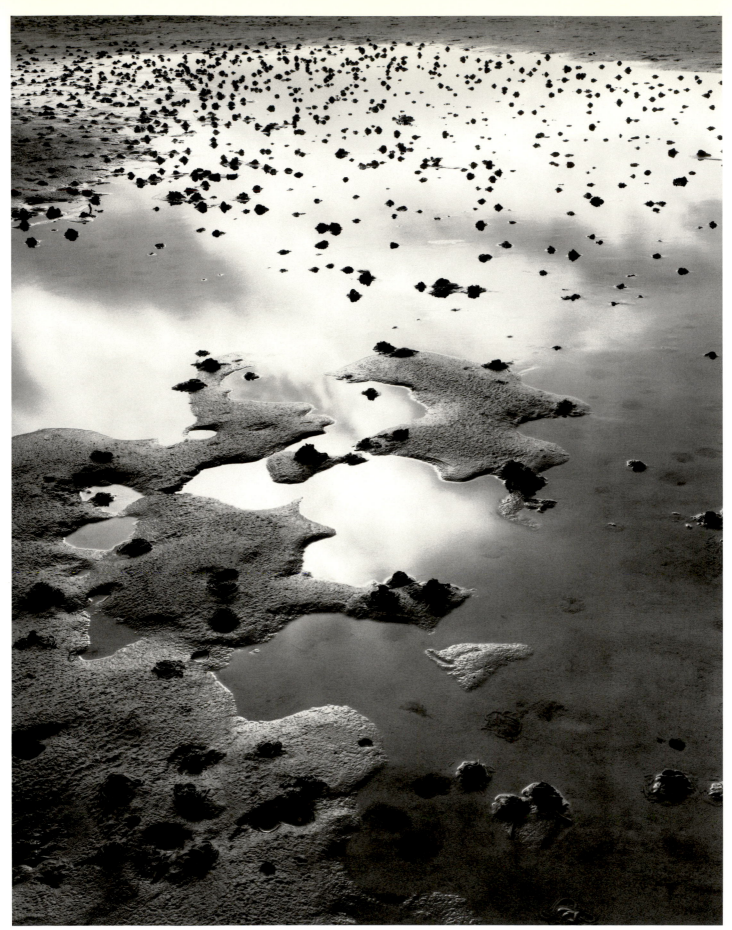

WORM CASTS, *Luskentyre, Isle of Harris 1976*

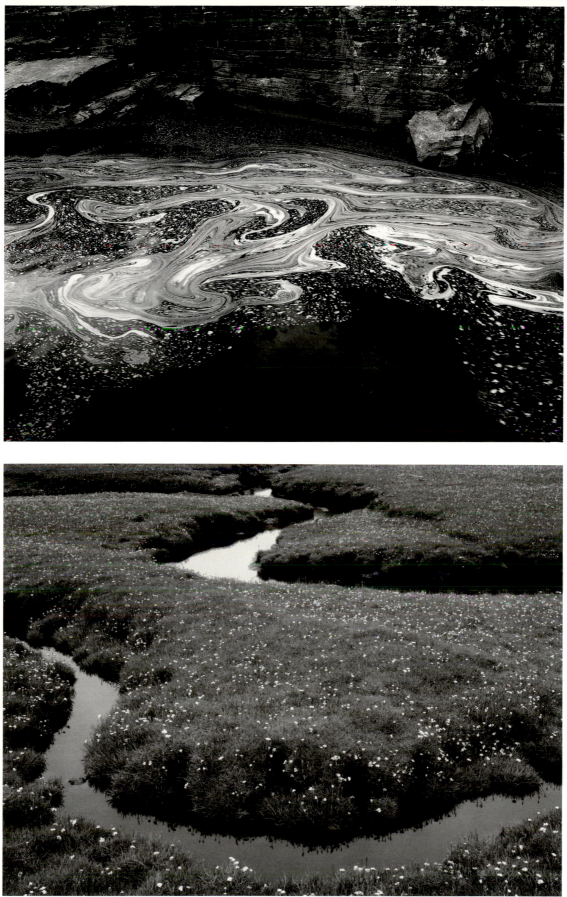

SALT GRASS, *Luskentyre, Isle of Harris 1976*

OAK TREES, *The Trossachs 1983*

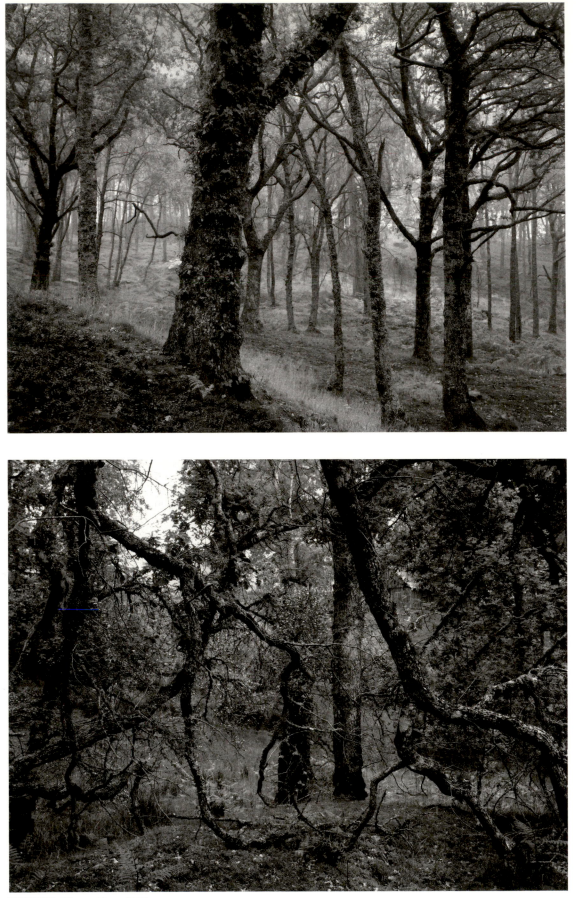

FOREST, *Wester Ross 1980*

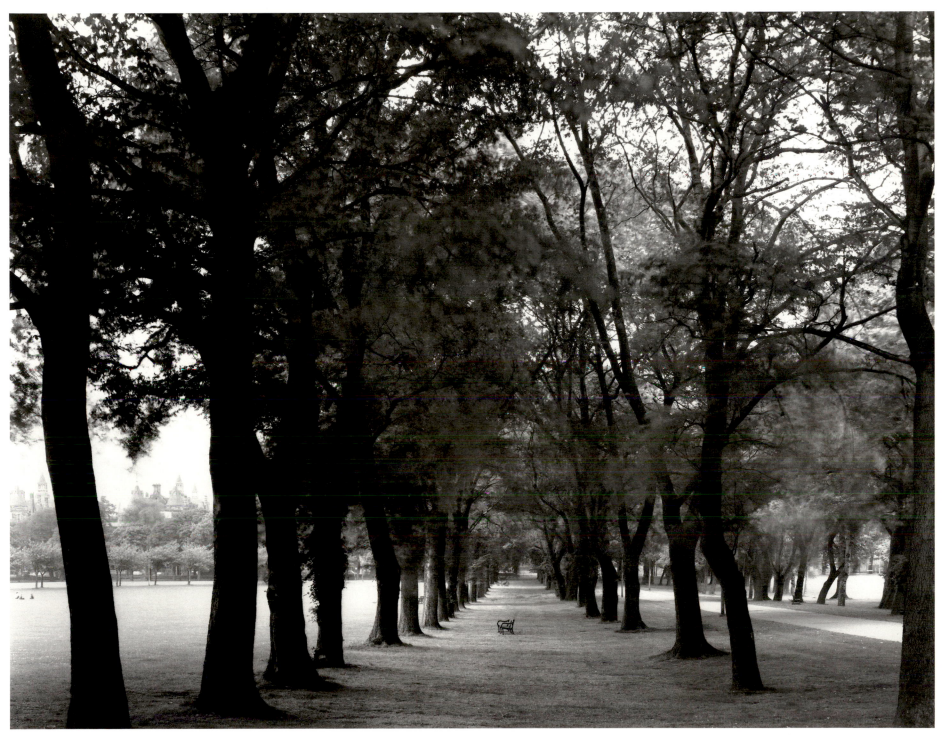

PARK BENCH, *The Meadows, Edinburgh 1977*

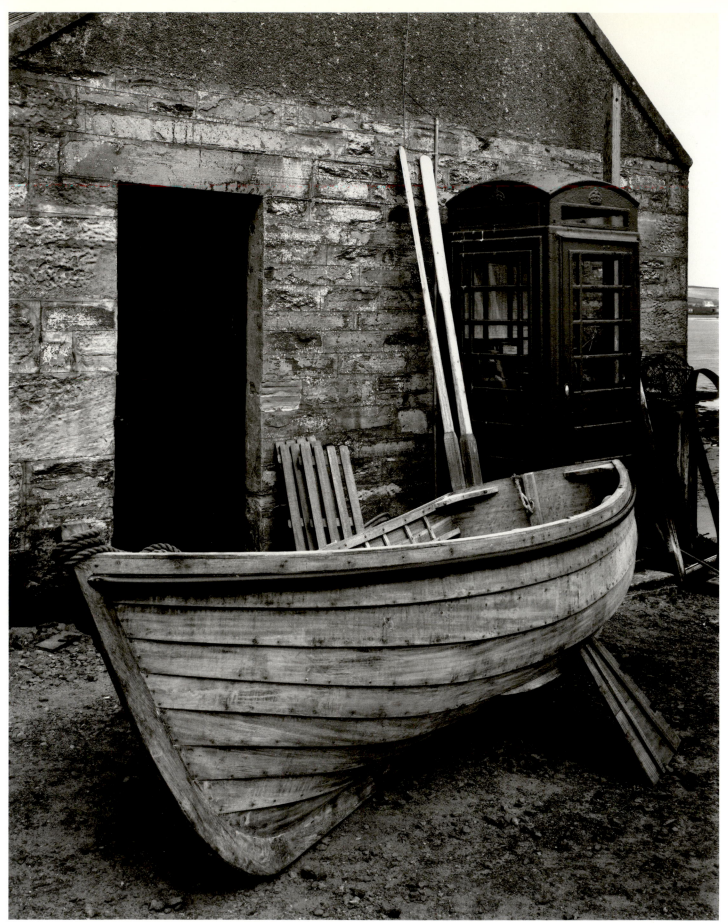

BOAT AND PHONE BOOTH, *Scapa Pier, Orkney Islands 1977*

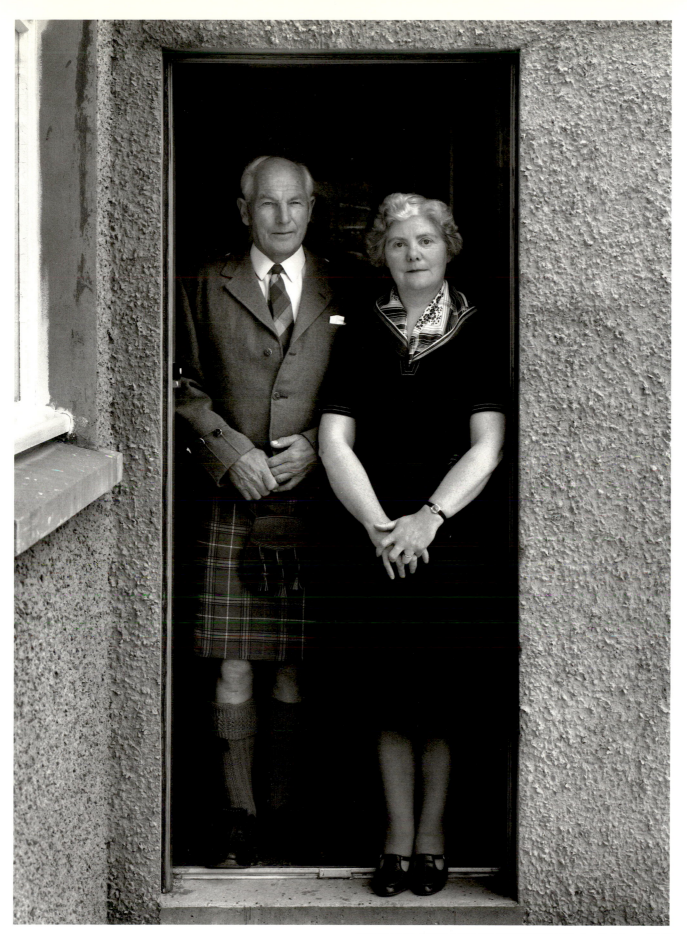

DONALD AND MOLLY BUCHANAN, *South Morar 1980*

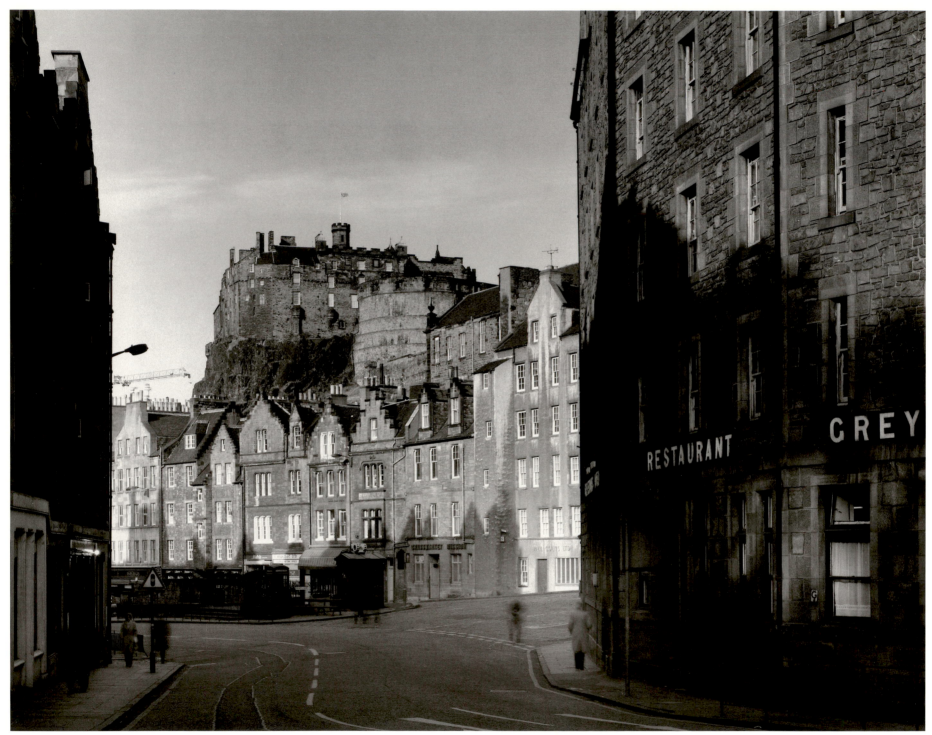

CASTLE FROM THE GRASSMARKET, *Edinburgh 1983*

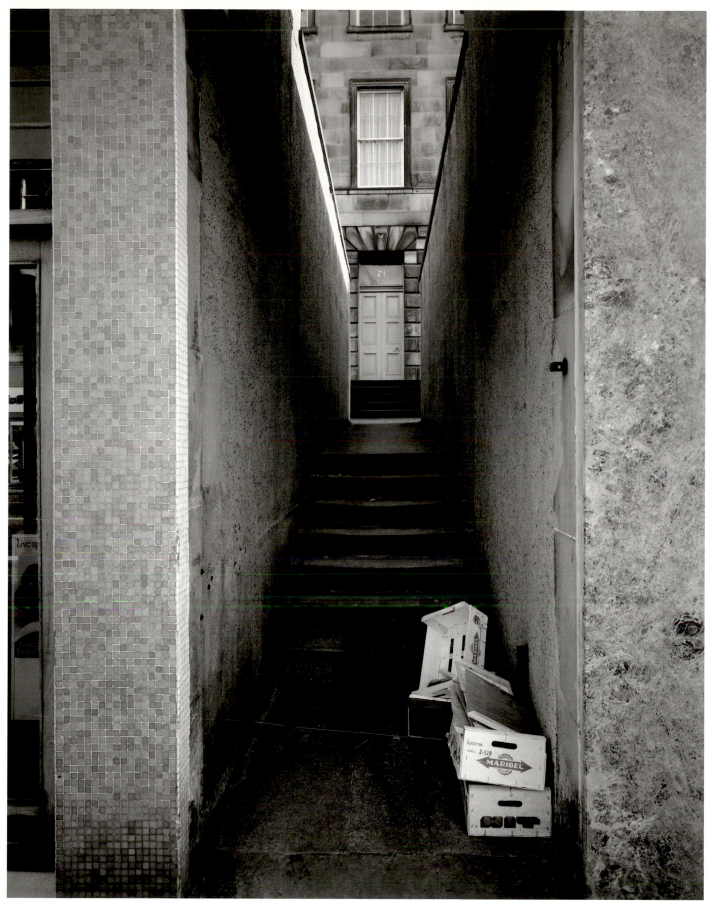

#71 NEWINGTON ROAD, *Edinburgh 1983*

WOMEN

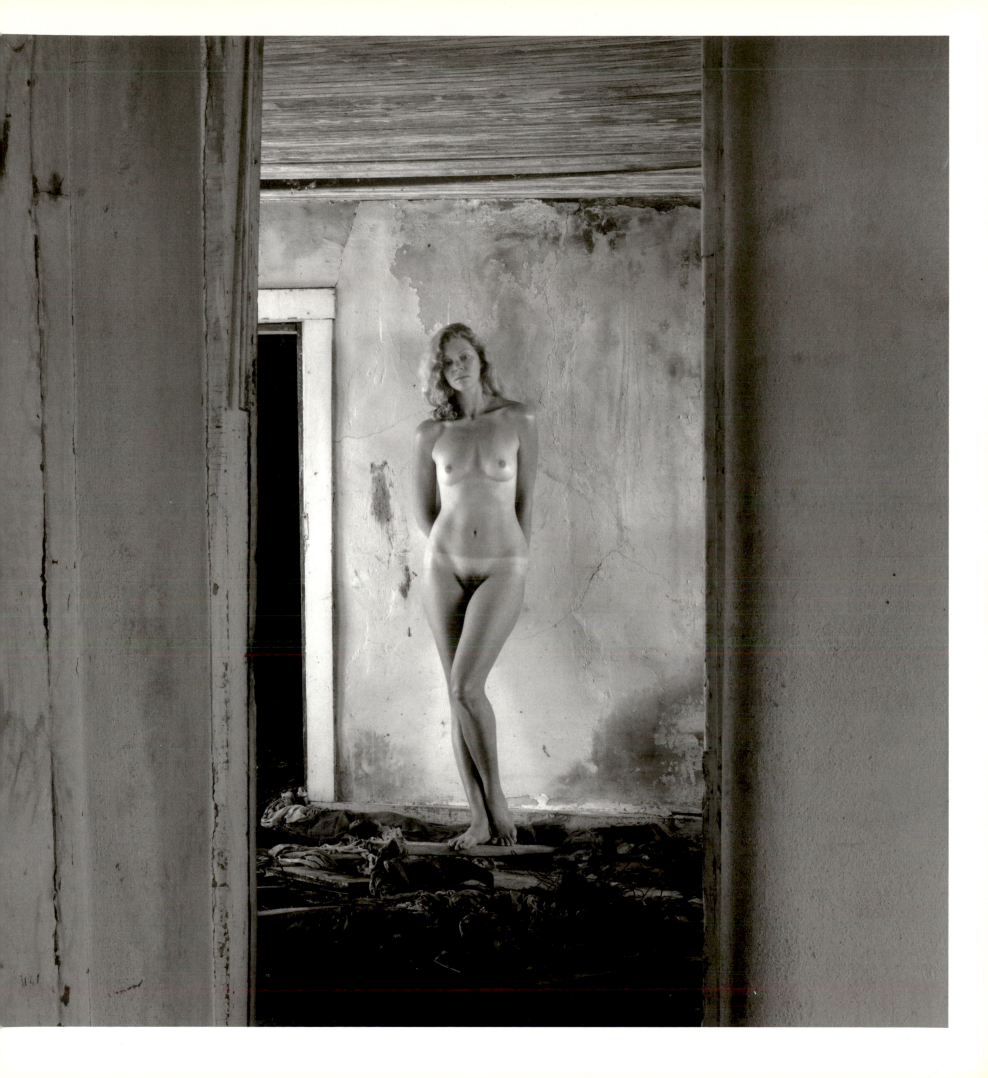

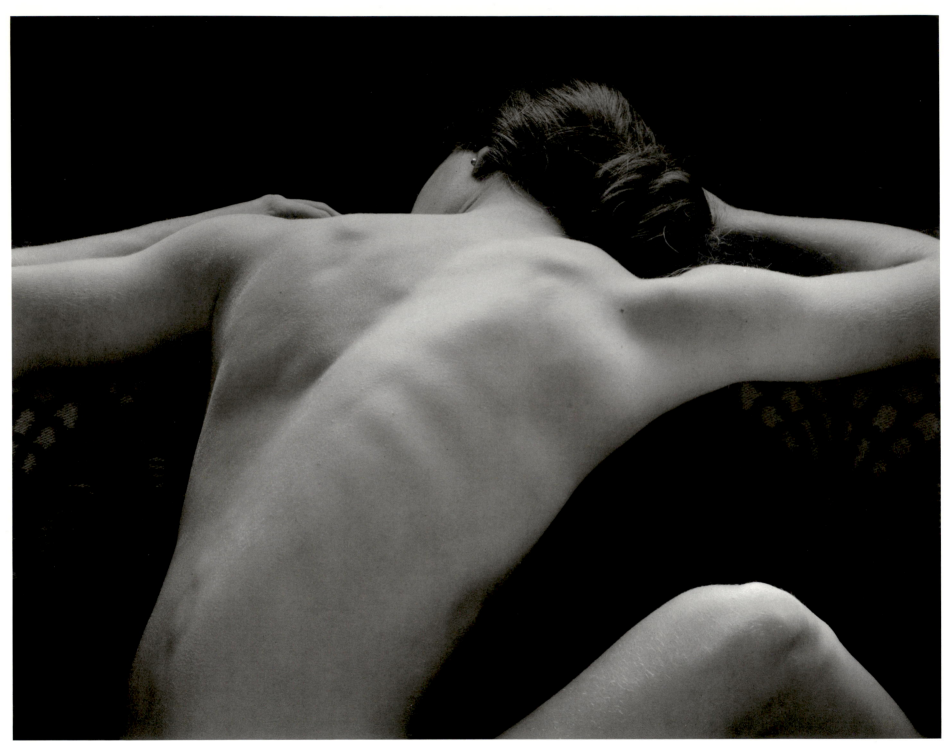

G BACK, 1972

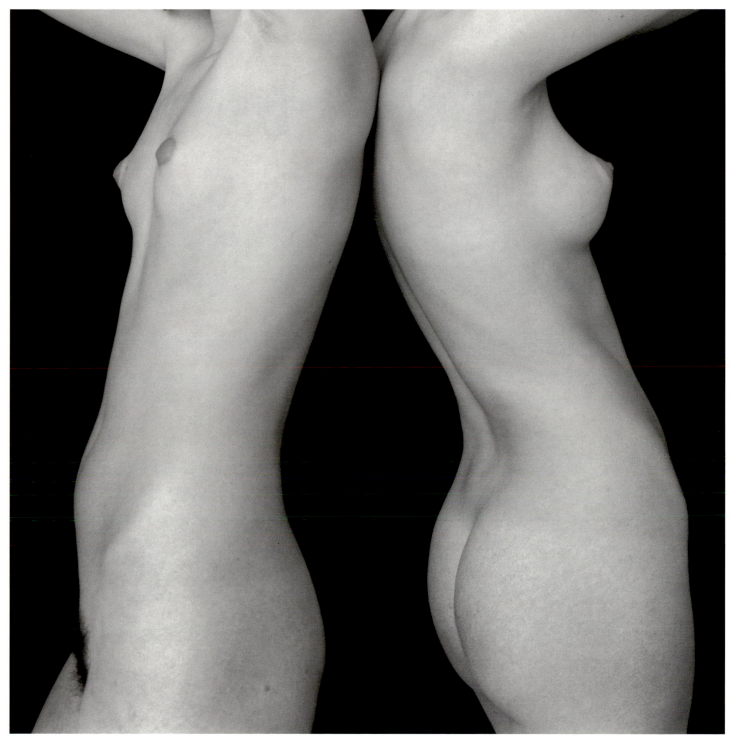

DOUBLE NUDE, *1974*

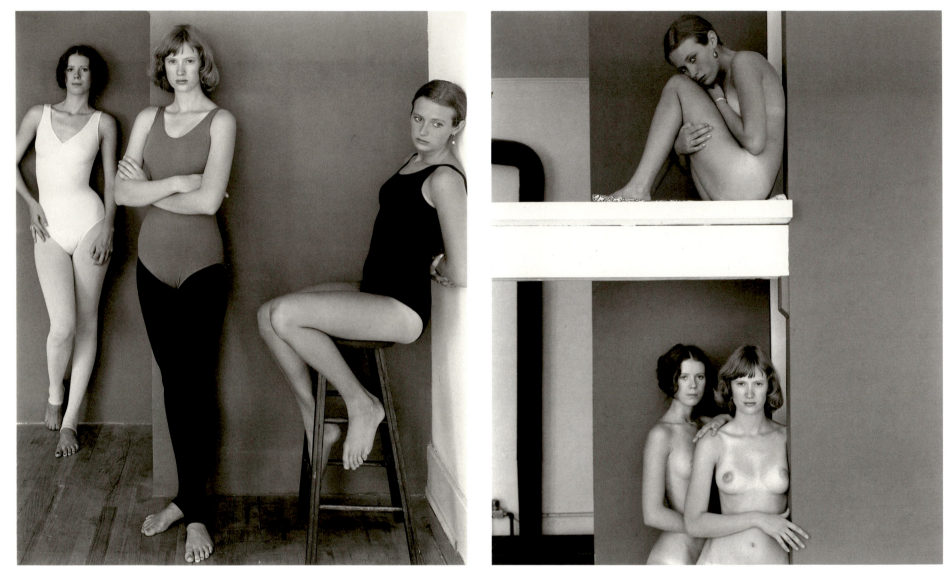

THREE SISTERS, *1975*

THREE SISTERS NUDE, *1975*

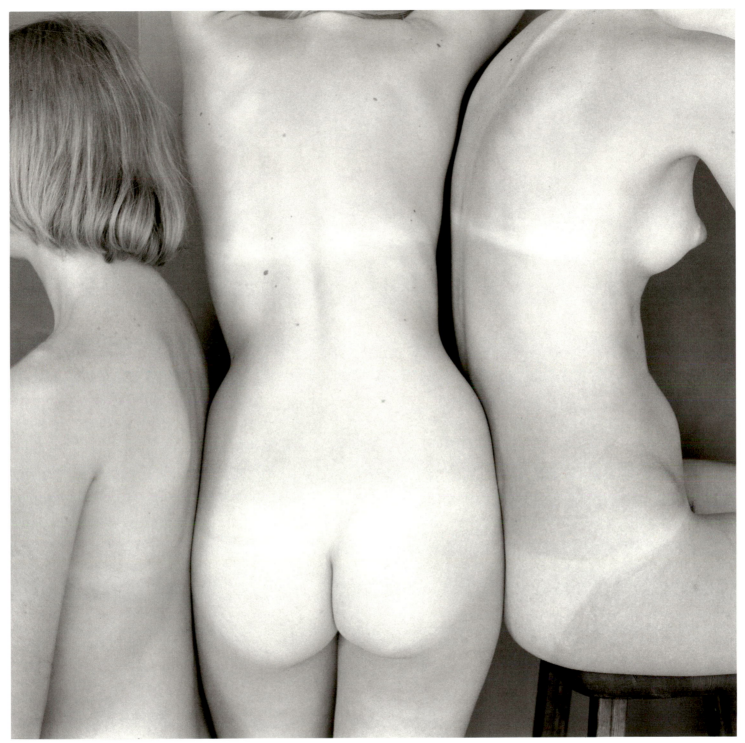

TRIPLE NUDE, *1975*

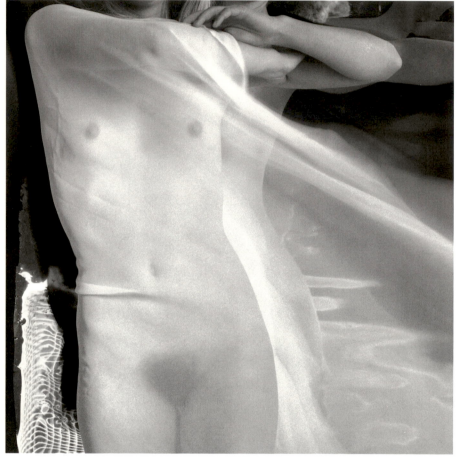

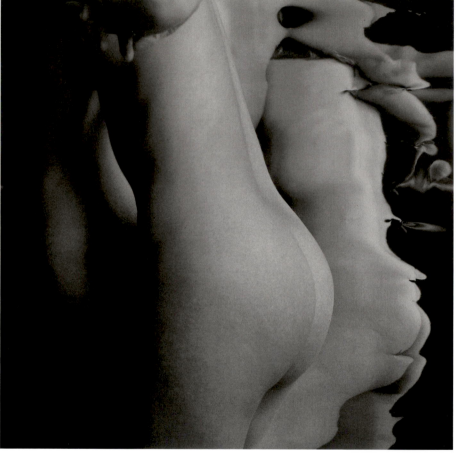

FLOWING FABRIC, *1981*

TORSOS AND MYLAR, *1980*

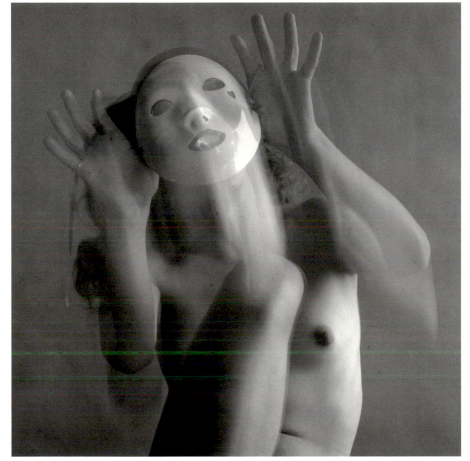

MOVING MASK, *1981*

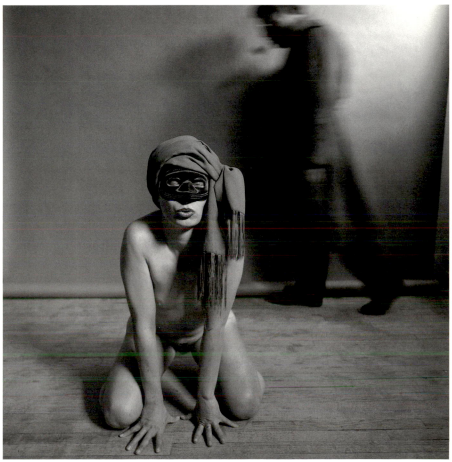

TRENCH COAT SELF-PORTRAIT, *1981*

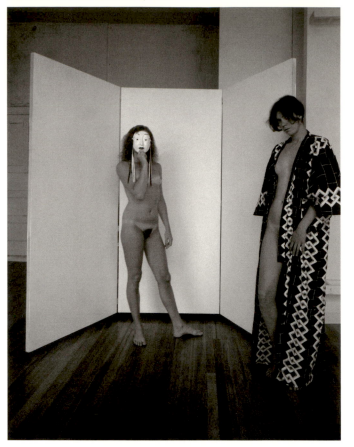

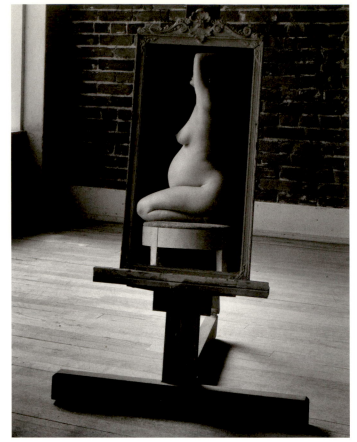

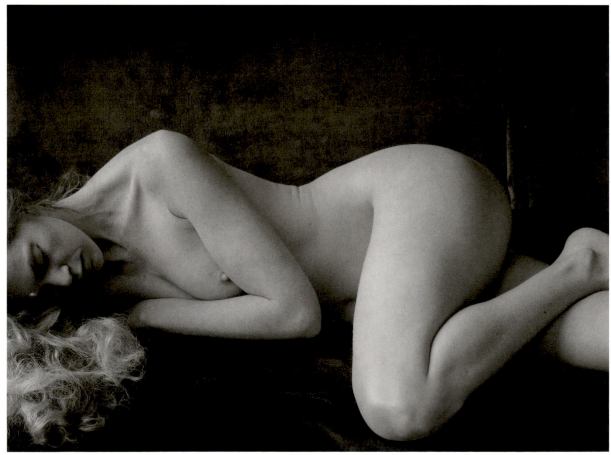

JAN RECLINING, *1980*

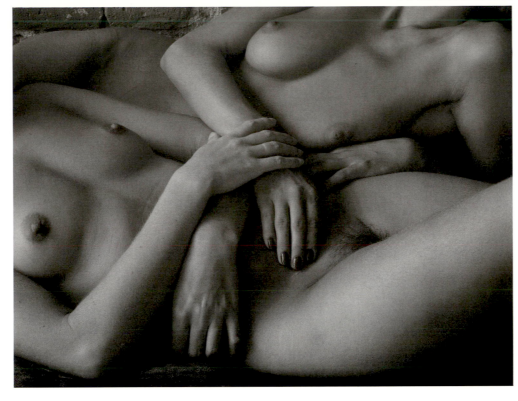

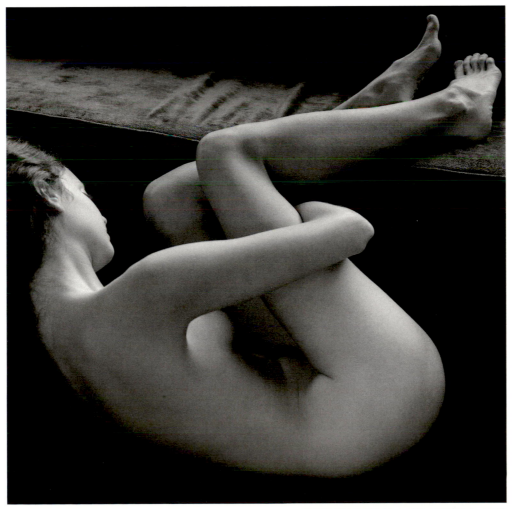

CURLED NUDE AND COUCH, *1972*

WHITE SANDS NUDE, *1976*

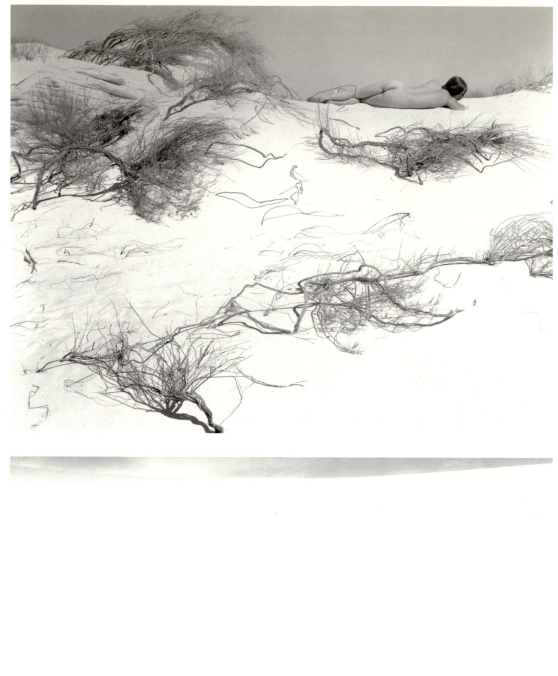

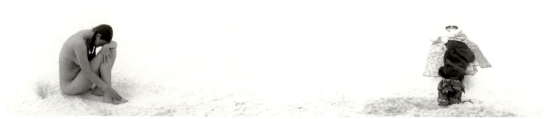

WHITE SANDS NUDE WITH CLOTHES, *1976*

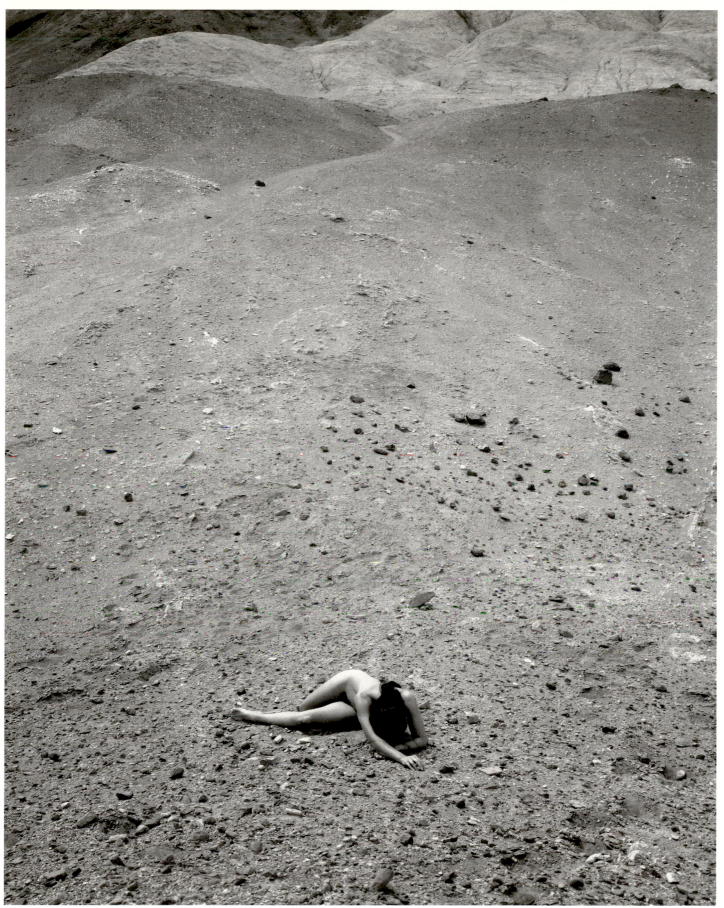

DEATH VALLEY NUDE, *1973*

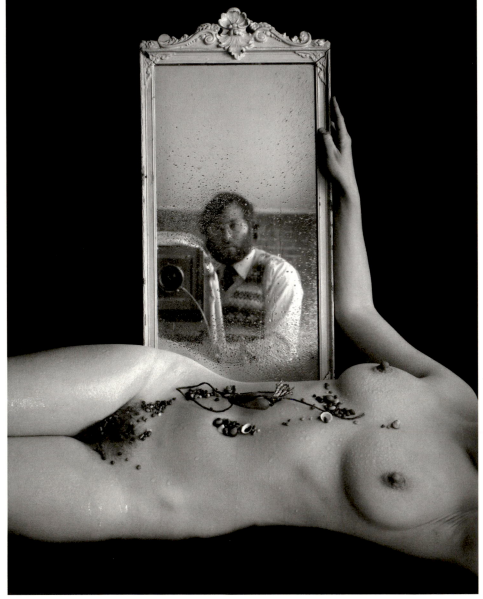

SELF-PORTRAIT IN MIRROR, 1979

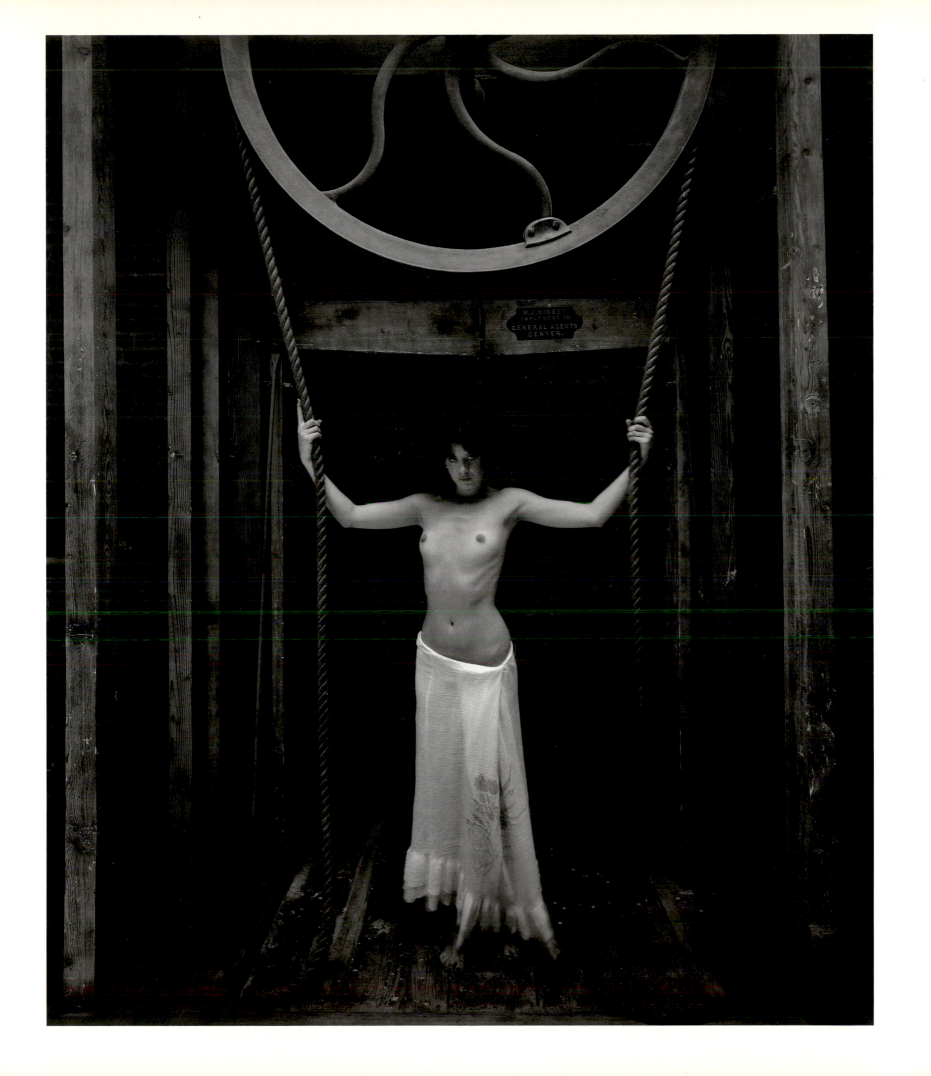

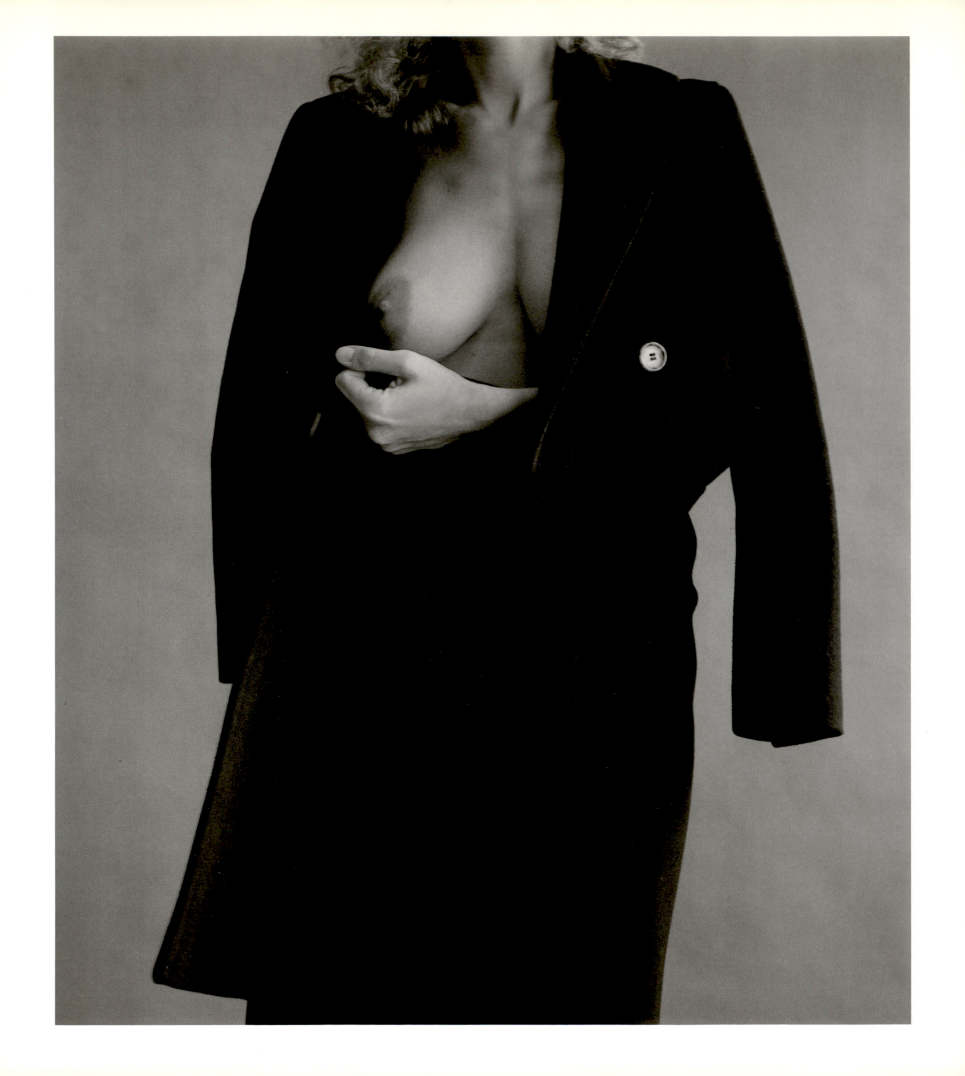

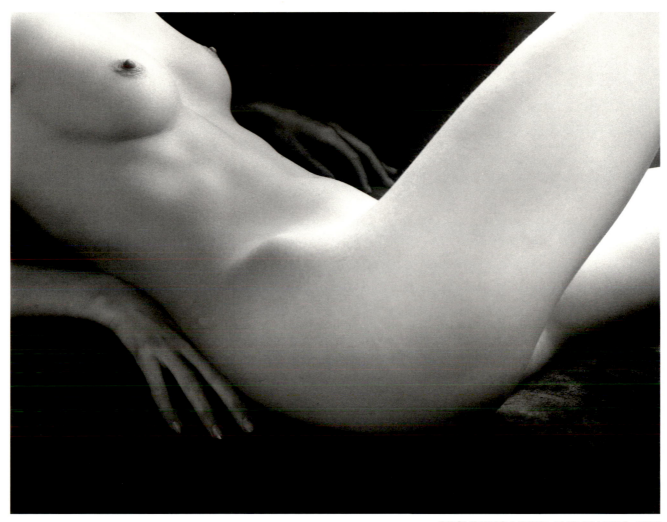

RECLINING NUDE AND HANDS, *1972*

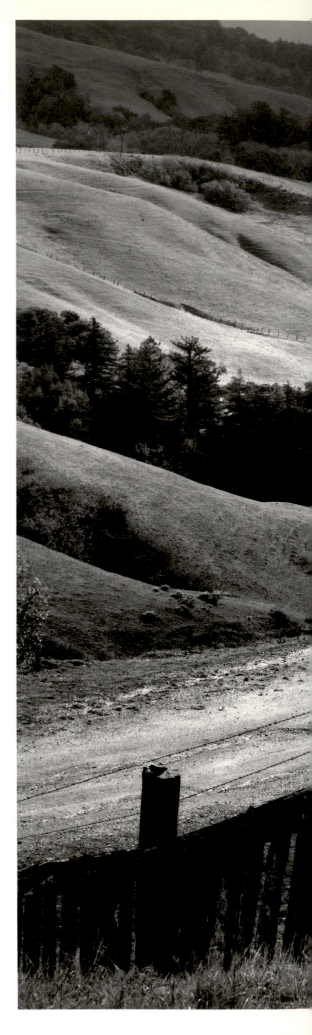

LANDSCAPES

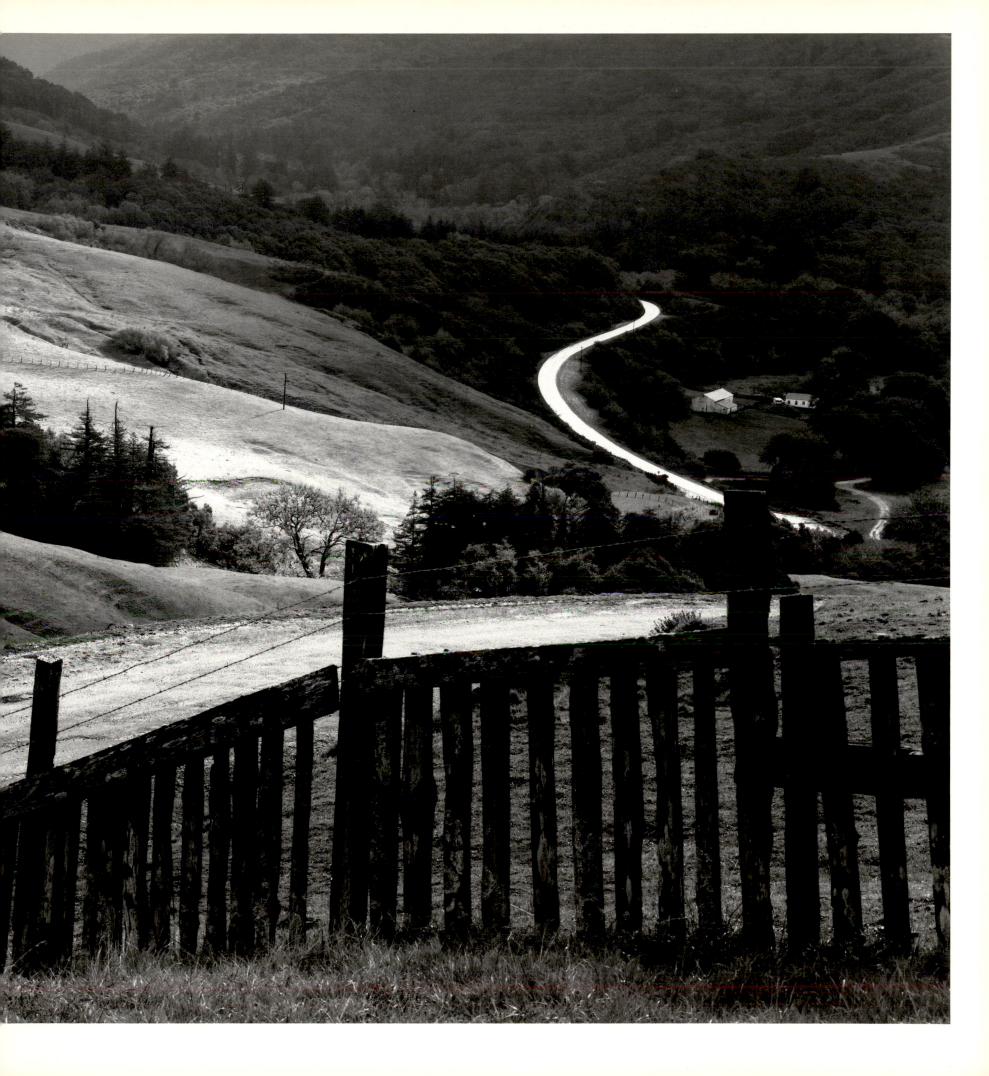

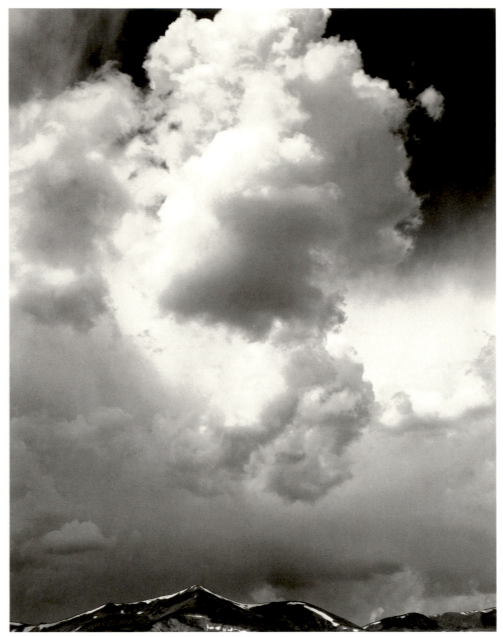

STORM CLOUD, *Breckenridge, Colorado 1975*

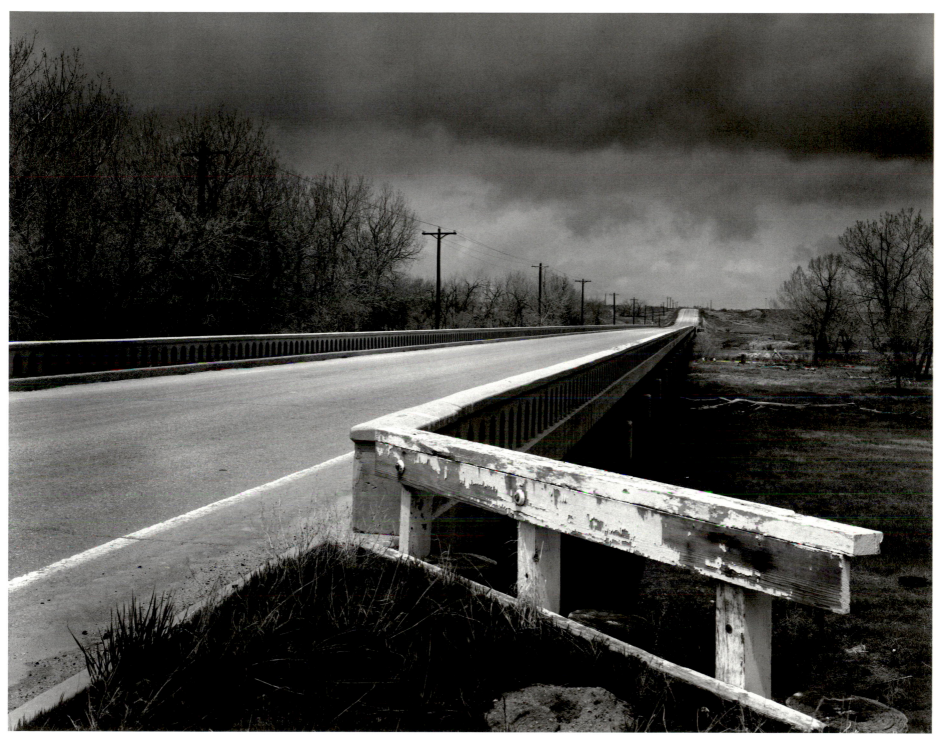

BRIDGE OVER KIOWA CREEK, *Colorado 1983*

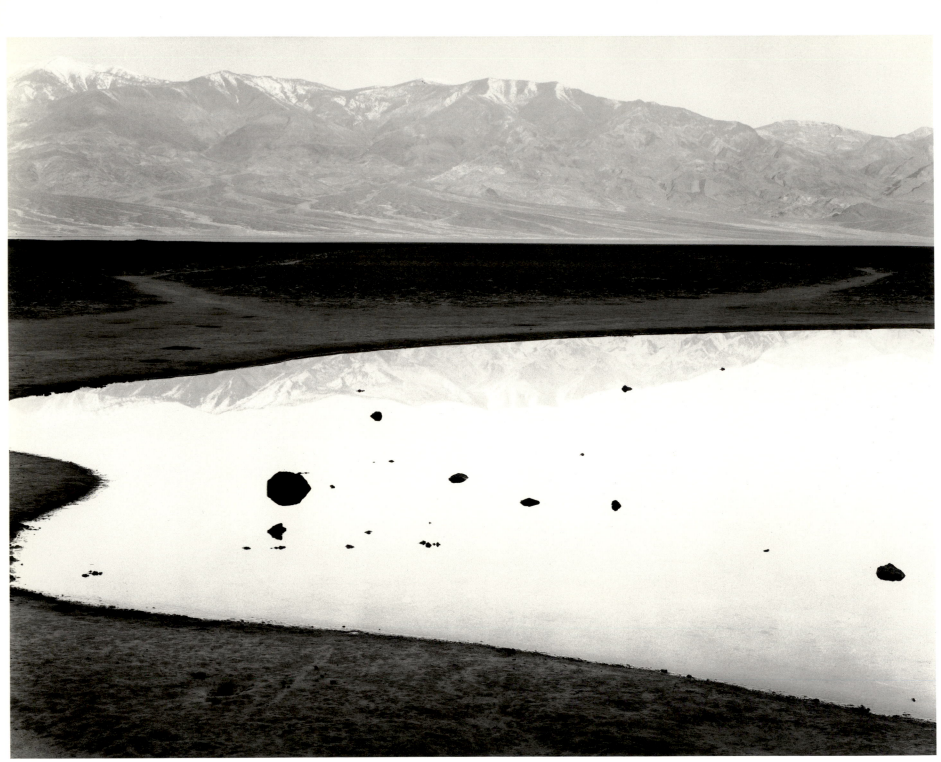

BADWATER, *Death Valley, California 1973*

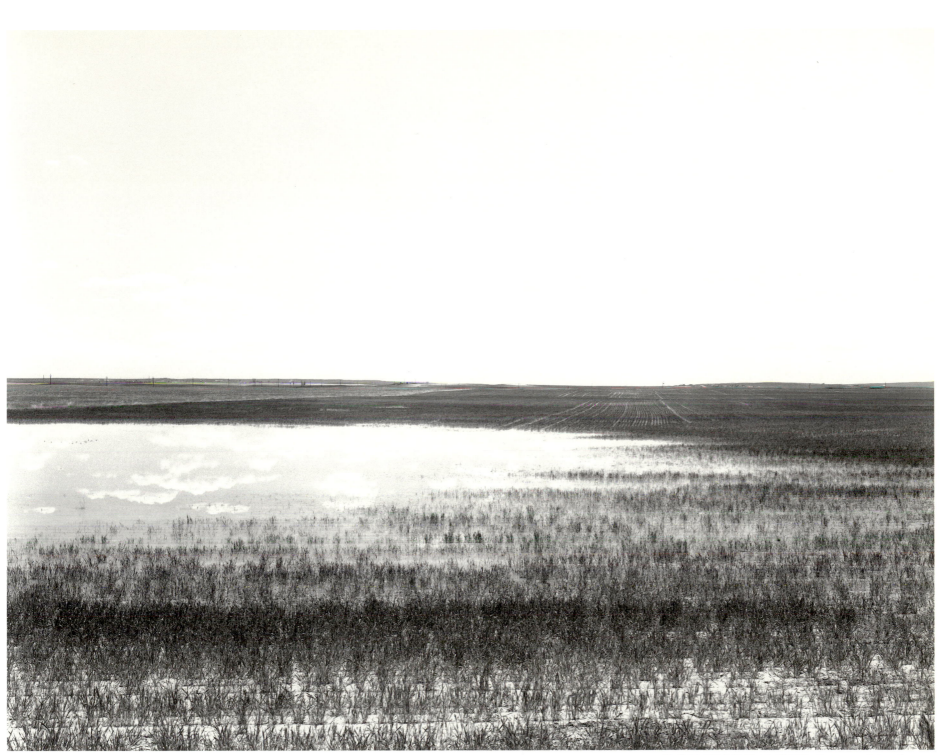

FLOODED WHEAT FIELD, *Bennett, Colorado 1983*

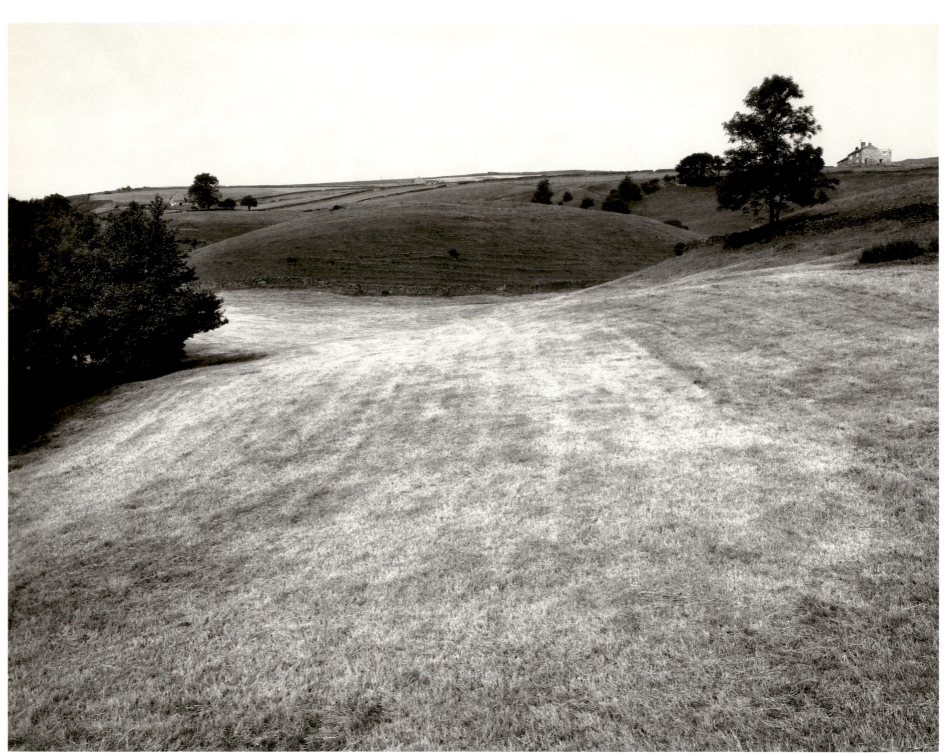

ARKENGARTHDALE, *Yorkshire, England 1976*

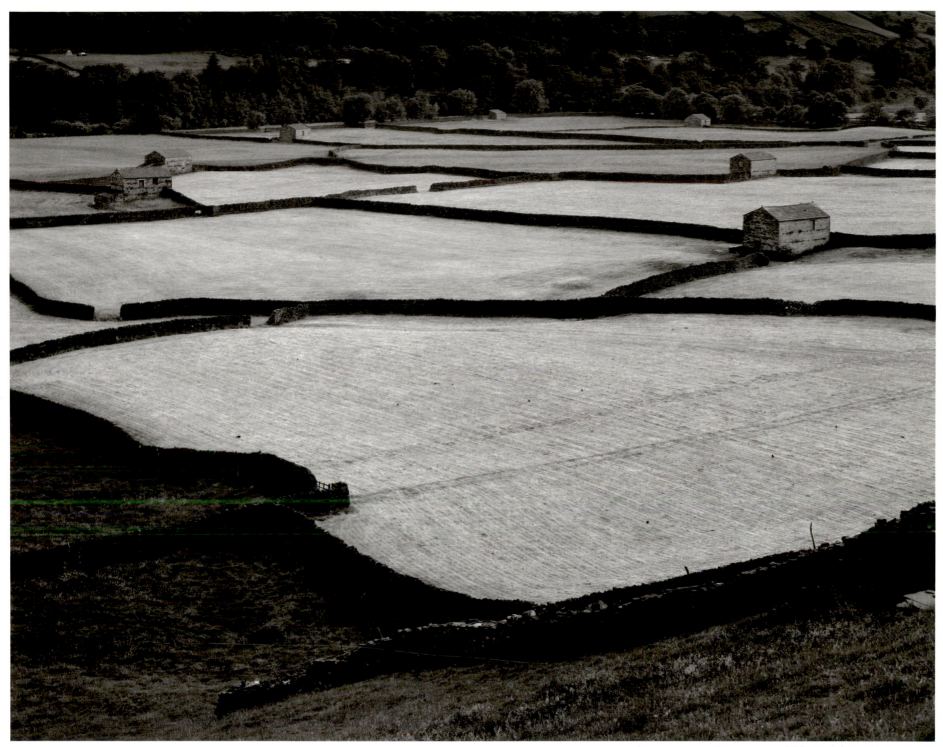

STONE BARNS AND FENCES, *Yorkshire, England 1976*

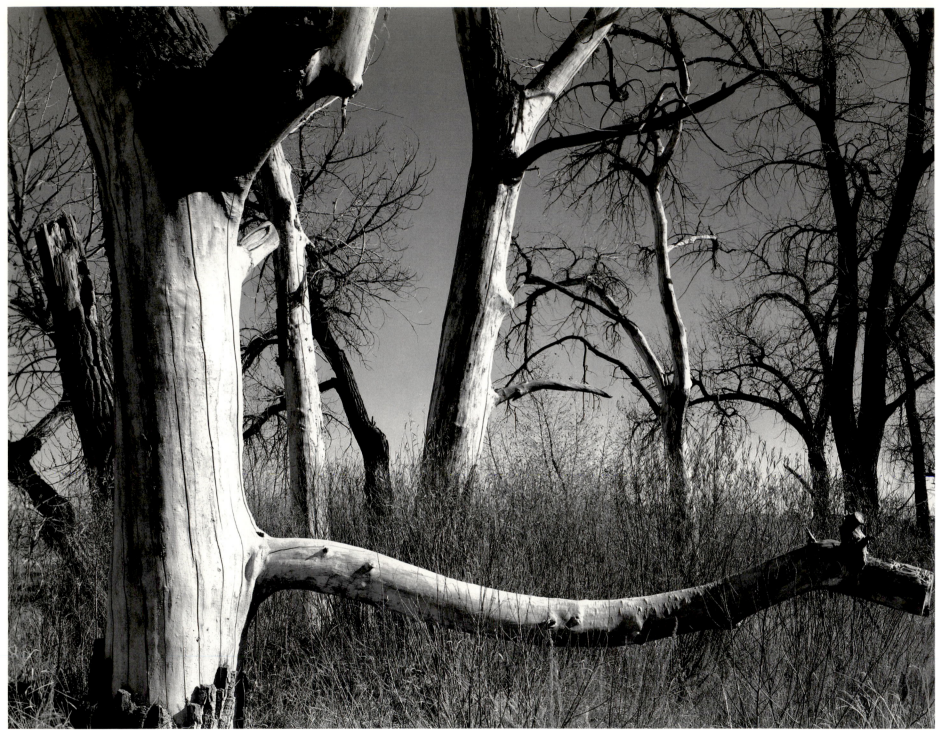

COTTONWOOD TREES, *Cherry Creek, Colorado 1979*

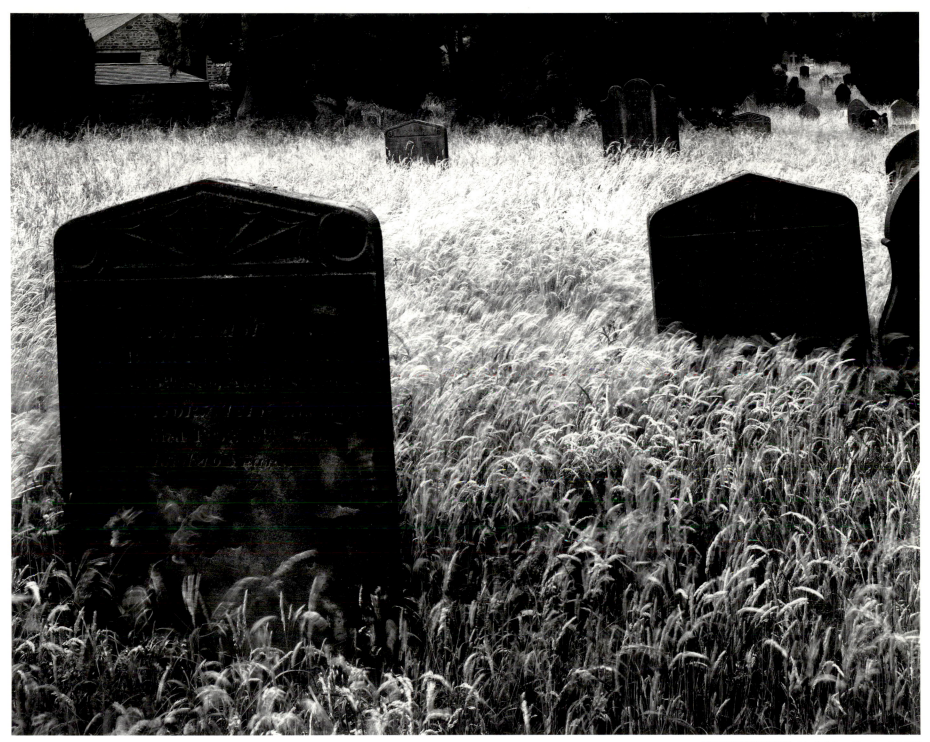

GRAVESTONES, *Yorkshire, England 1976*

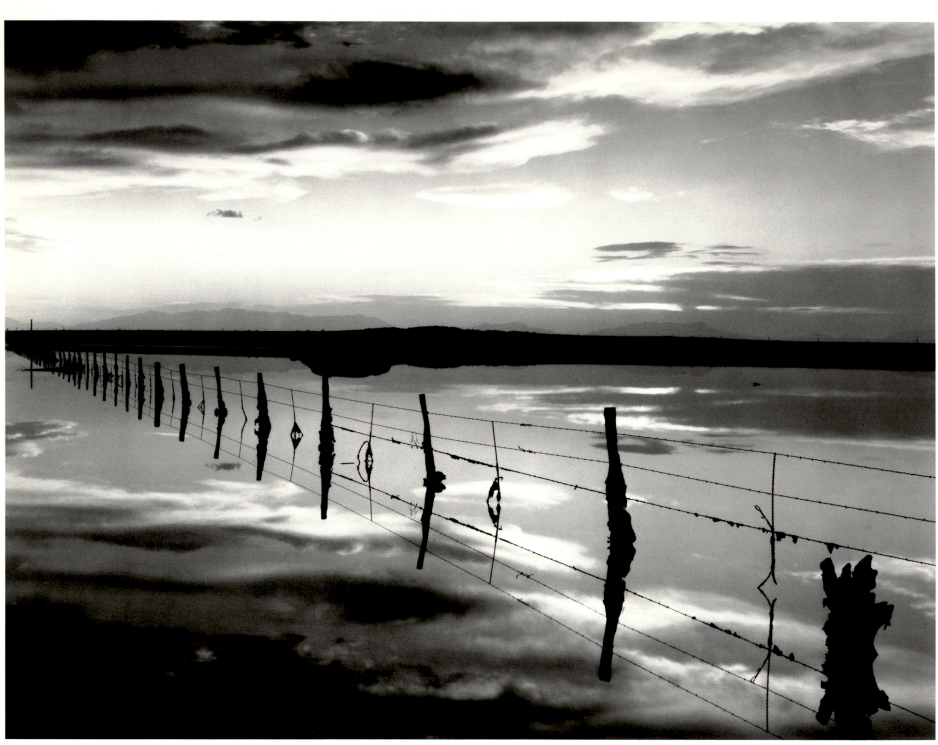

BLACK FENCE, *White Sands, New Mexico 1976*

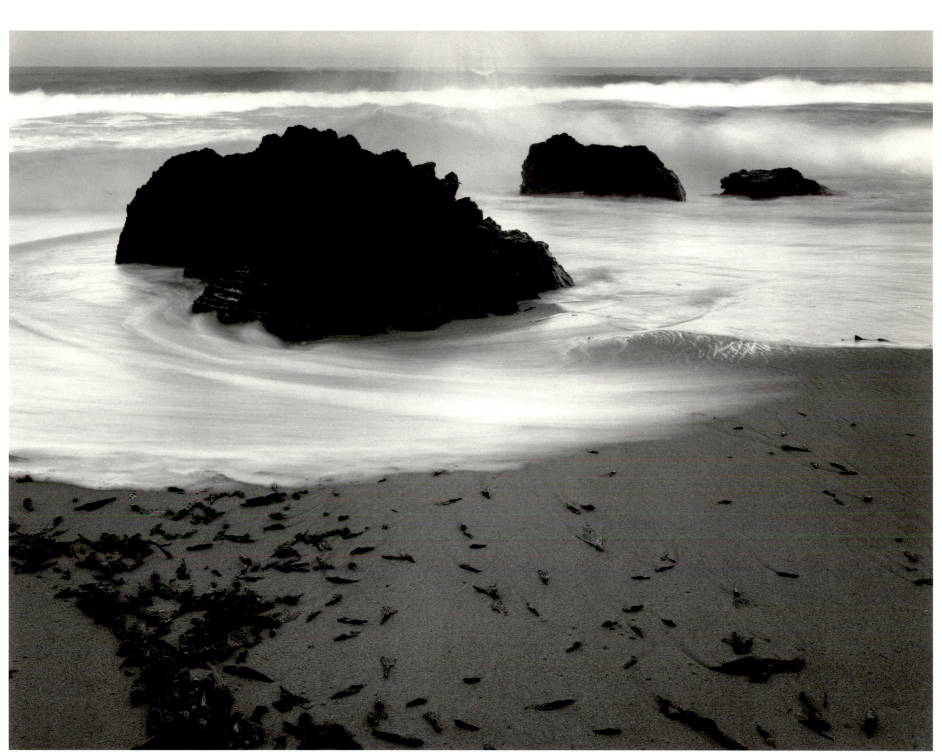

THREE ROCKS AND SURF, *California 1974*

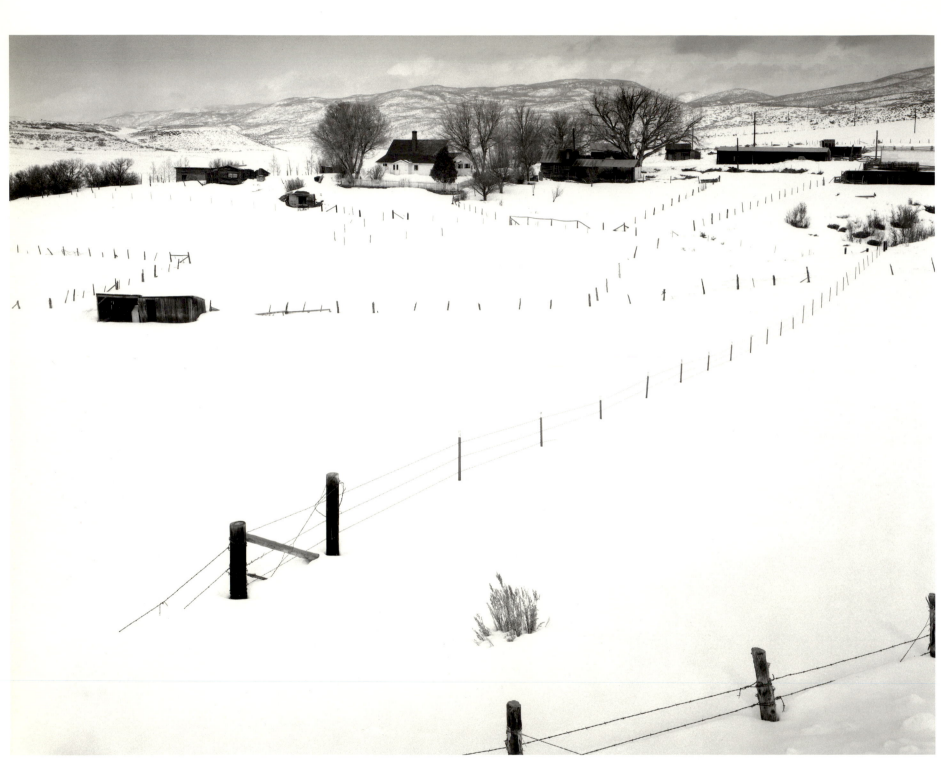

WINTER FARM, *Colorado 1975*

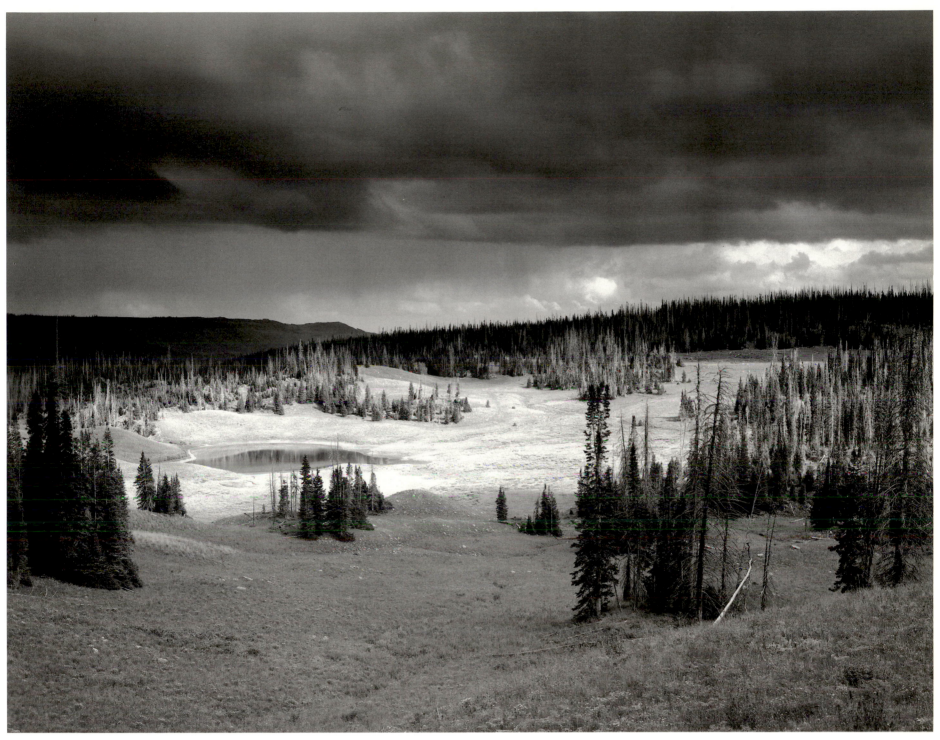

FLAT TOPS WILDERNESS, *Colorado 1975*

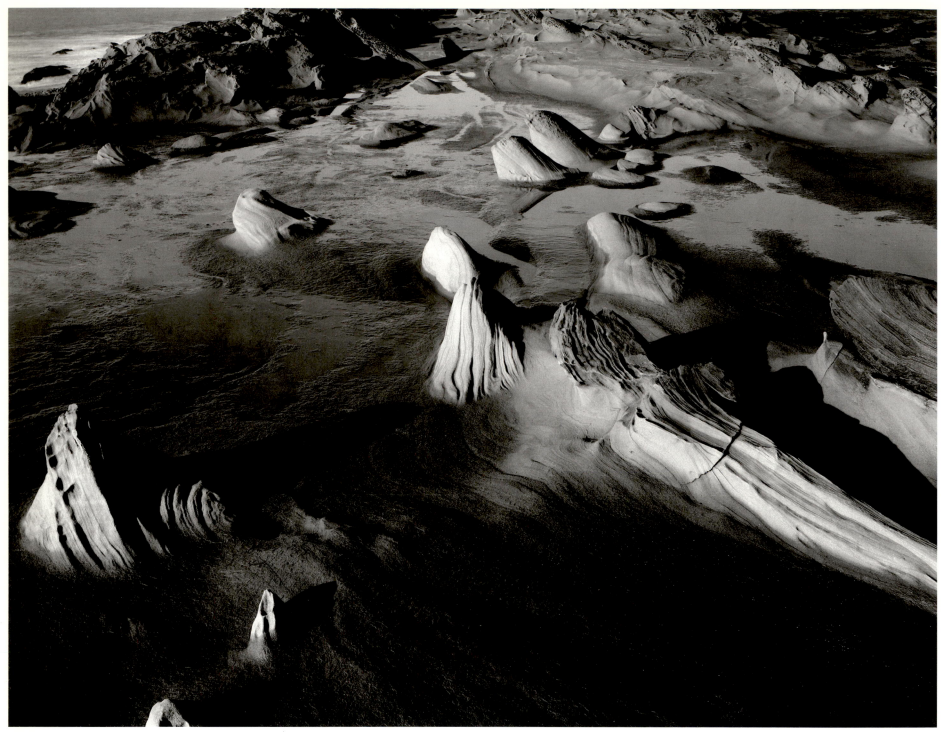

ROCK FORMS, *Cape Arago, Oregon 1974*

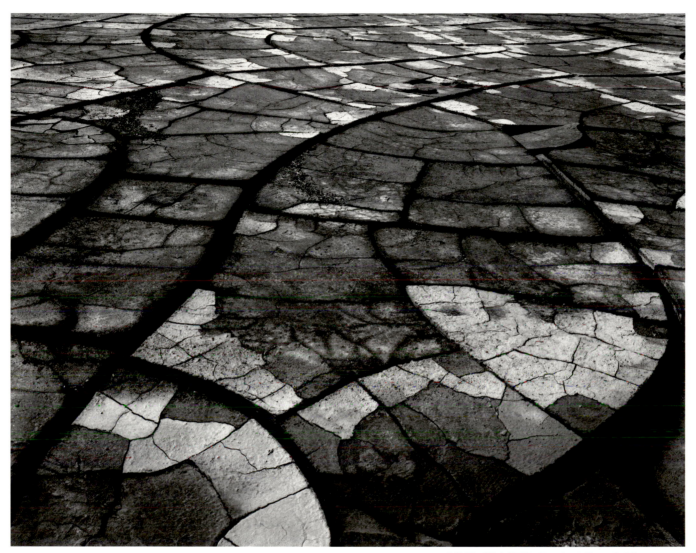

MUD CRACKS, *Death Valley, California 1973*

I came to photography trained as a historian. In 1970, with an M.A. in history under my belt, I embarked on a doctoral program at Cambridge University in England. I loved the tweedy intellectual atmosphere, my black scholar's gown, and the intelligent academic stimulation. But pedalling to the library one morning I realized that I was framing each street corner and park bench into black and white rectangles. My enthusiasm for Tudor Constitutional Law was no match for my passion for photography, and I would have to choose between them. It was a wrenching conclusion. During spring break I made a pilgrimage to Carmel, California and, with my best photographs stylishly wrapped in a brown grocery bag, I presented myself for an audience with Ansel Adams, hoping he would discover me. He was polite. He sent me to the University of Oregon to "polish my technique" and in 1973 I received a Masters Degree in Photography.

I have never regretted starting my career in this way. History teaches that observation precedes analysis and keen attention to detail is a virtue.

In writing my Masters thesis on Brett Weston I was introduced to a cadre of talented people whose influences I gratefully acknowledge. From Brett, I learned the meaning of single-minded dedication to one's work. Morley Baer taught me that a photographer's most important tool is the part that stands on two feet behind the camera. Ansel Adams was generous with students; as a college teacher I try to follow his example. The mystery of Wynn Bullock's prints startled me.

During this same time, I was made dizzy by two dazzling museum exhibits, one by Edward Weston, the other by Paul Strand. I've never been the same since.

Moreover, I learned that an artistic gift is nothing without craft.

I am an ardent admirer of Scotland whose closets bulge with Harris Tweed coats and wool caps too numerous to mention and too hot to wear in Denver, Colorado where I make my home. These were acquired during four photographic trips to Britain. I possess an authentic Highland sheep crook, a black and white collie dog and share my life with two small boys, Max and Frank, who know all the best spots to photograph — preferably near ant piles and mud holes. My wife Robin is a first class creative consultant and executive administrator, and I have dragged them all to the edge of the earth in search of the great photographic opportunity.

SELF-PORTRAIT

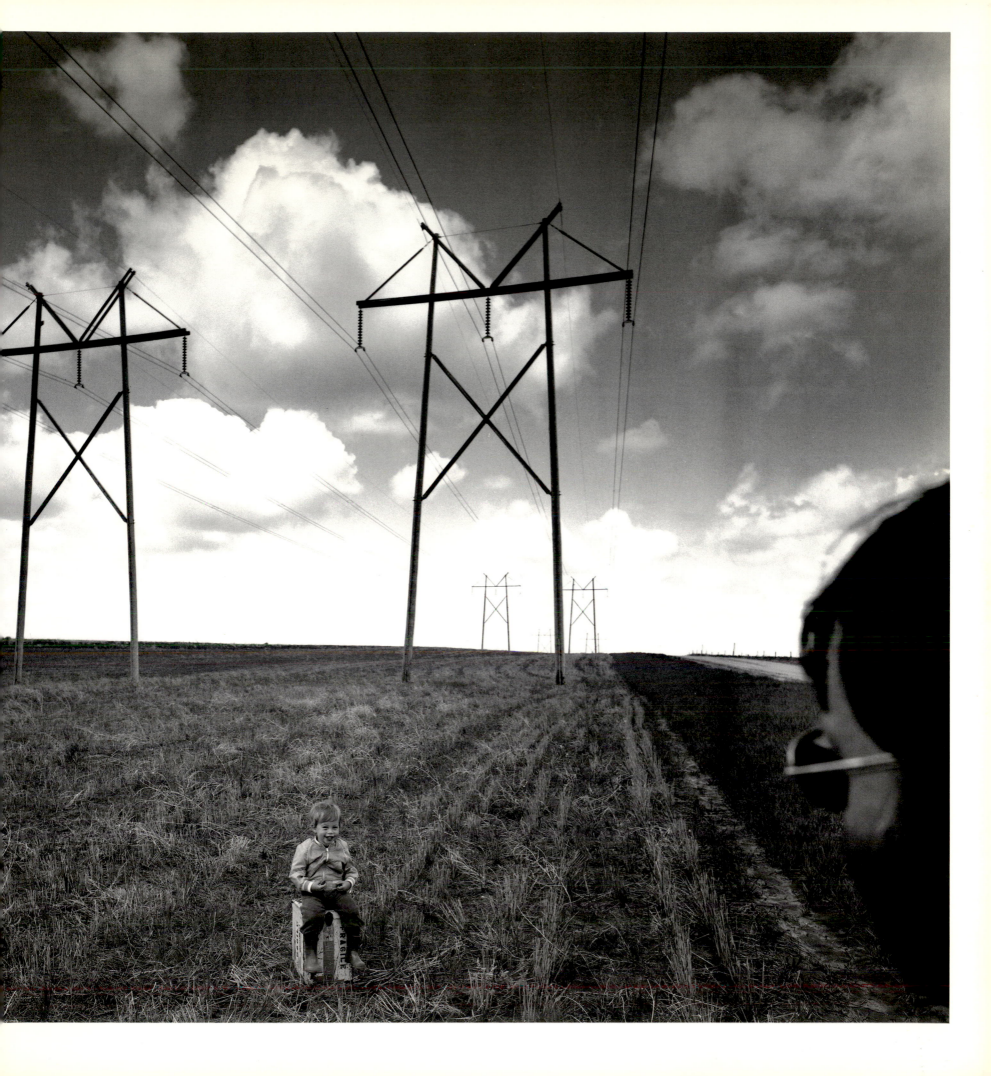

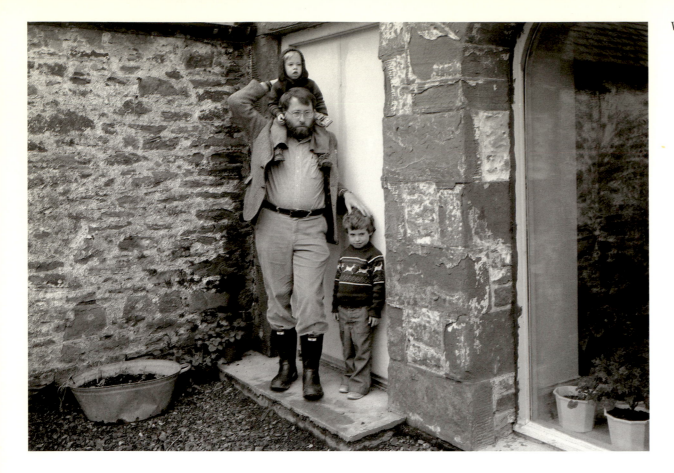

ACKNOWLEDGMENTS

Gardner/Fulmer Lithograph printed this book to their usual exacting standards. The laser scanned Fultone® negatives were also done by their expert staff.

James Ray and Jack Ruff created a design for this book that reveals a true understanding and appreciation of my photographs.

Joyce and Ted Strauss provided substantial support to this project.

Ruth Wohlauer and Hannah Levy stood by me from the beginning.

TECHNICAL

Most of the photographs in this book were made with an 8 X 10 view camera using normal or slightly longer than normal focal length lenses. For portraits and nudes I occasionally use a 4 x 5 view camera and a 2¼ single lens reflex camera. Although I use the Zone System for exposure, I still prefer to develop my negatives by inspection. I make contact prints on an extinct brand of paper stockpiled throughout the city in my relatives' freezers. Enlargements from 8 x 10 negatives are made on ordinary paper, normal grades, in a homemade enlarger.

My work is found in numerous public and private collections and is handled by galleries throughout the country.

I have printed two limited edition portfolios — "Scotland", 1981 and "Landscapes", 1983, each containing twelve 11 x 14 prints made from 8 X 10 negatives.